TECHNIQUES OF
NATURAL LIGHT
PHOTOGRAPHY

TECHNIQUES OF
NATURAL LIGHT
PHOTOGRAPHY

JIM ZUCKERMAN

WRITER'S DIGEST BOOKS

Cincinnati, Ohio

778.76
Z8t

Techniques of Natural Light Photography. Copyright ©
1996 by Jim Zuckerman. Printed and bound in Hong Kong.
All rights reserved. No part of this book may be reproduced in
any form or by any electronic or mechanical means including
information storage and retrieval systems without permission
in writing from the publisher, except by a reviewer, who may
quote brief passages in a review. Published by Writer's Digest
Books, an imprint of F&W Publications, Inc., 1507 Dana
Avenue, Cincinnati, Ohio 45207. (800) 289-0963. First
edition.

Other fine Writer's Digest Books are available from your local
bookstore or direct from the publisher.

00 99 98 97 5 4 3 2

Library of Congress Cataloging-in-Publication Data

Zuckerman, Jim.
 Techniques of natural light photography / Jim
Zuckerman.
 p. cm.
 Includes index.
 ISBN 0-89879-716-0 (alk. paper)
 1. Available light photography. I. Title.
TR590.Z834 1995
778.7'6—dc20 95-34728
 CIP

Edited by Mary Cropper
Designed by Brian Roeth

About the Author

Jim Zuckerman left his medical studies in 1970 to turn his love of photography into a career. He has taught creative photography at many universities and private schools, including the University of California at Los Angeles and Kent State University in Ohio. He also leads many international photo tours to destinations such as Burma, Thailand, China, Brazil, Eastern Europe, Tahiti, Alaska, Greece and the American Southwest.

Zuckerman specializes in wildlife and nature photography, travel photography, photo- and electron microscopy, and special effects. He recently has applied his talents to computer manipulation, producing a new generation of cutting edge imagery that would have been impossible only a few years ago.

Zuckerman is a contributing editor to *Peterson's Photographic Magazine*. His images, articles and photo features have been published in scores of books and magazines including several Time-Life books, publications of the National Geographic Society, *Outdoor Photographer*, *Outdoor and Travel Photography*, *Omni* magazine, *Conde Nast Traveler*, *Science Fiction Age*, Australia's *Photo World*, and Greece's *Opticon*. He is the author of three other photography books: *Visual Impact, The Professional Photographer's Guide to Shooting and Selling Nature and Wildlife Photos*, and *Outstanding Special Effects on a Limited Budget*.

His work has been used for packaging, advertising and editorial layouts in thirty countries. It has also appeared in calendars, posters, greeting cards and corporate publications. His stock photography is represented by Westlight in Los Angeles.

Acknowledgments

I am deeply appreciative to Mary Cropper for believing in this book from the beginning and for nurturing it through the many stages of approval. Her clear, organized thinking was a tremendous asset in helping me present the information herein.

I'd also like to thank Katie Carroll, the production editor, for overseeing the project and making sure all the loose ends were taken care of. And to Clare Finney, who had the initial artistic vision for the book, and to Brian Roeth, the designer, I am grateful for their making my photography look so good.

To Rondi, who has given me the greatest gift of all.

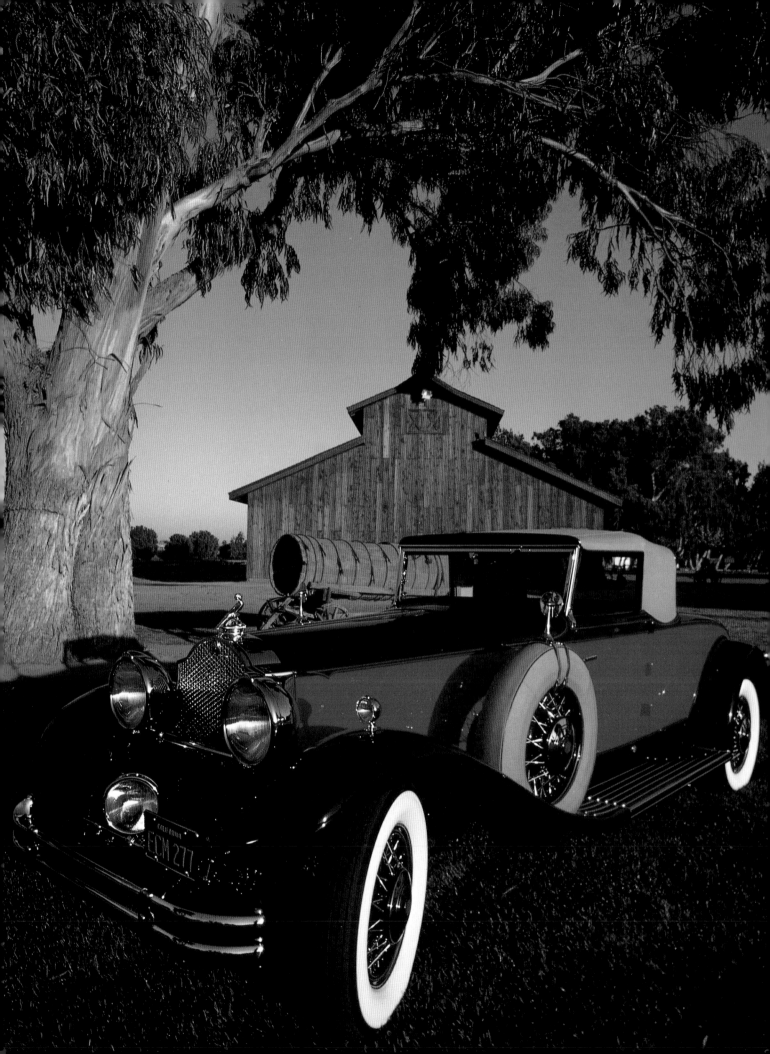

Table of Contents

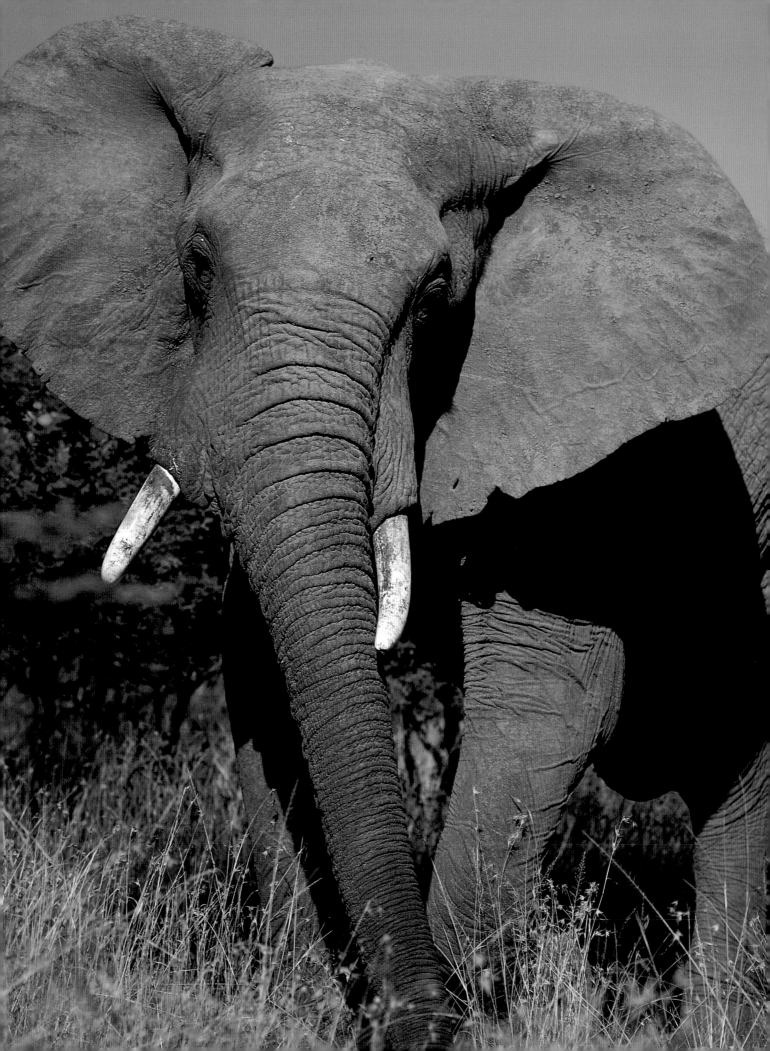

Introduction

Light is one of the two fundamental aspects of photography that make or break a picture (the other is composition). Whether it is subtle or dramatic, the impact of light on an image completely alters how that image is perceived. Understanding how to use light is essential to creating powerful photographs.

Natural light, the subject of this book, is the light provided us by the sky. It is tremendously diverse, ranging from fantastic bolts of lightning to winter whiteouts, from cobalt blue twilight to bright sun. Nature's light has many qualities that photographers use as creative tools in making images. Among these qualities are direction, diffusion, harshness and color. Each of these characteristics affects the way a subject appears both to our eyes and to film. The direction of light has a direct impact on shadows and texture. When light is diffused, as it is under an overcast sky, or when the natural light is harsh, during midday sun, objects will appear either soft with little contrast or garish with a high degree of contrast. The color of light varies greatly, depending on the time of day. The wide range of natural hues impacts an image perhaps more emotionally than technically.

The camera's position relative to the subject determines if the light is coming from the front, back or side. Each of these directions creates a different kind of picture, depending on the nature of the subject. An opaque object, like a tree or a human form, can be silhouetted by backlighting, but the light coming *through* a leaf, or other nearly transparent object, makes it translucent. Although the results are quite different, both effects are produced by a strong, directional light coming from behind the subject. Understanding these qualities can enable you to previsualize a landscape, cityscape or model at a particular time of day. If you plan ahead and take advantage of optimal lighting conditions, the quality of your photos will take a quantum leap forward.

Intellectually, it is not difficult to understand the qualities of light. Incorporating them into your photography is another matter. This can take years. I can tell you that my own photography has matured over the past twenty-five years, but it has been a slow process. Don't be impatient. Just love the wonder of making exciting images, apply the techniques in this and other photo books, and watch your own artistry develop.

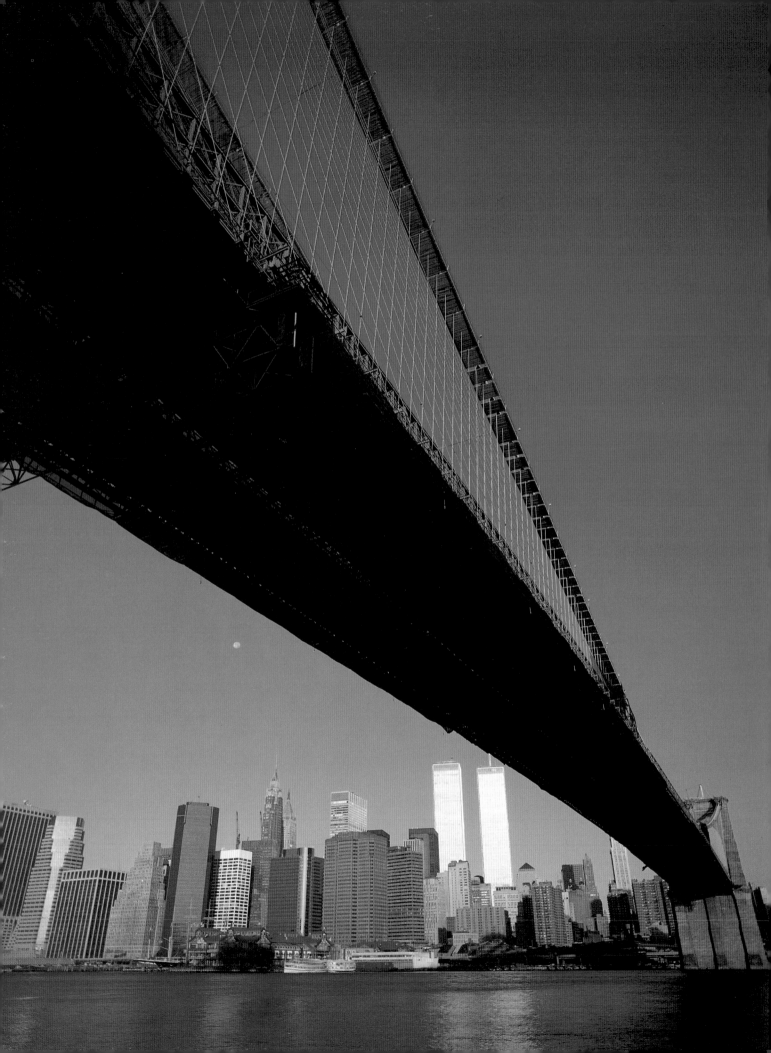

Sunrise

Many types of lighting make great pictures. When we speak of natural or available light, the first type that often comes to mind is the light created by a bright sun in a blue sky with puffy clouds. But there are other types of lighting that are more beautiful and much more dramatic. This chapter illustrates two of my favorite natural lighting conditions, dawn and sunrise. The beautiful glow in the eastern sky at dawn and the low-angled, golden lighting at sunrise makes everything we see appear wonderful and magical. The same qualities that delight us when we greet the dawn can also transform photos, as you'll see in this chapter.

Unless outdoor shooters can—and want to—drag along a heap of equipment, they have to work with the light naturally available or wait until conditions change. In order to work well with natural light, you have to master the fine art of selecting the correct exposure for each shot. There are many circumstances, including dawn and sunrise lighting, where light meters can't give you an accurate exposure because of the brilliant highlights or deep shadows in a particular composition. It's critical, therefore, that you understand how to determine the correct f/stop-shutter speed combination even in tricky situations.

There are two basic types of light meters—reflective and incident. Reflective meters read the light entering the lens as it is *reflected* off the subjects in front of your camera. These meters interpret the world in tonal values, often described as shades of gray. Grays provide a simple system for defining tonal values, but every color has several values. Is a leaf light green or dark green? Is a flower red or bright red? The "correct" exposure you get from the meter is based on the area of the scene that it "sees" as the middle-toned or medium gray part.

Reflective meters can give you incorrect readings because they are programmed to think strictly in terms of medium gray. If you're shooting white snow, the reflective meter reads the snow (the largest tonal area) as medium gray. The reading causes you to underexpose the picture, and the snow comes out looking gray. You can compensate for this problem, however, if you select a middle-toned area of your composition and take the meter reading from that instead. You can also use a medium gray camera bag, blue jeans, a khaki photo jacket or a section of blue sky as the middle tone for your reading. After you take the reading, switch your camera off automatic exposure, set the aperture and shutter speed, and make your shot.

The most convenient meter to use is the reflective meter built into your camera, frequently called a "Through-The-Lens" (TTL) meter. Most TTL meters can function either as an averaging system or as a spot meter. In the averaging mode, the meter takes readings of the entire composition and averages them together. In the spot mode, it reads the light from the center portion of the frame, usually about twelve percent of the image area. A hand-held reflective meter does the same job, but some models are designed to be used as a very narrow spot meter. I use a Minolta Spot Meter F, which can take a light reading within a one degree angle, for example. The narrow reading lets me determine the exposure based on a very small portion of the scene. This is important when the critical area to read is very small.

Unlike reflective meters, a hand-held incident meter reads the light falling onto, rather than bouncing off, objects in the scene. That means it is virtually unaffected by brilliant highlights or deep shadows. However, an incident meter is only effective when the light striking the subject *is the same* as that falling upon the meter. For example, if you were standing in the shade of a tree, you couldn't take an accurate light reading on the sunlit areas in front of you unless you stepped out into the sunlight.

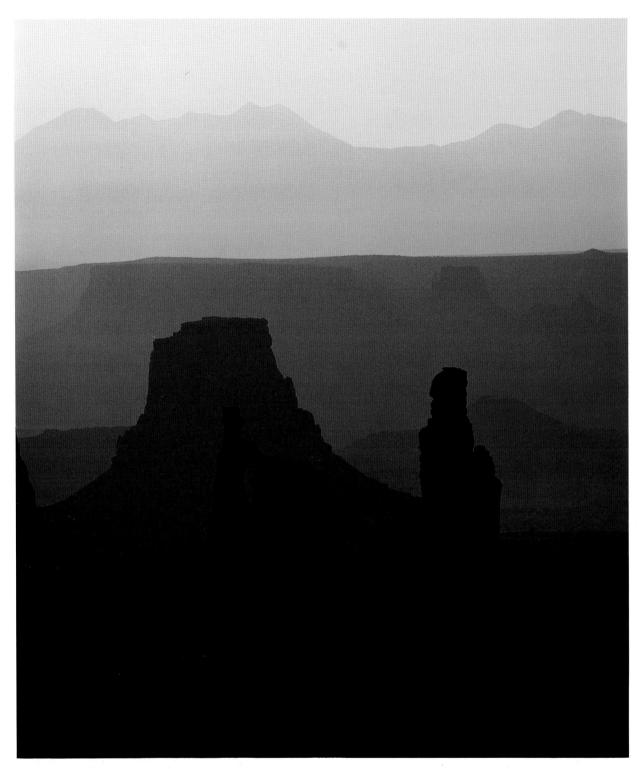

Why get up at some awful hour to shoot in the early morning? To get the benefit of the exquisite light. You can see the dramatic difference between sunrise lighting and mid-afternoon light in these two shots of Washer Woman Arch in Canyonlands National Park. The early morning photograph is rich in layered tonalities, where the dark, silhouetted arch is seen against succes-sively lighter gradations of outlined mountain ridges. The same composition taken in the flat afternoon light barely delineates the beautiful shapes that were so evident in the morning. In fact, it is difficult to distinguish the arch from the butte behind it.

The entire area of the photo taken in the afternoon, with the exception of the clouds and snow, is middle gray. Although it's not great lighting, your in-camera TTL meter will be its most reliable under these conditions. Since they are designed to interpret all lighting situations as a medium gray whether you're shooting the sun or the shadows on the forest floor, a middle-toned scene will photograph exactly as you see it.

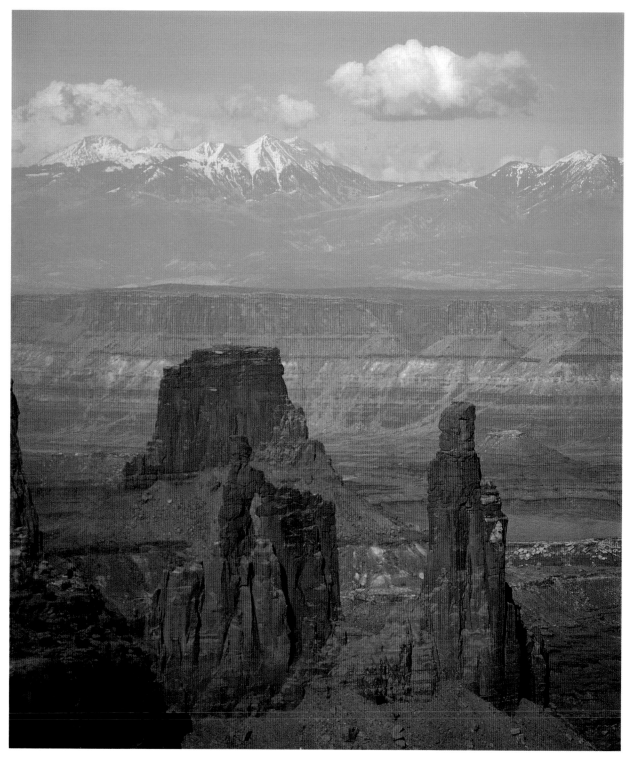

It is more challenging to take an accurate exposure reading at sunrise because the layers of tonality from very dark to almost white are tough for a meter to interpret. The meter can't know what you want to achieve, so it averages the exposure values. That average is based on how you compose the shot, the design of the meter and where exactly in the frame the meter's informa-tion is coming from. Since it's difficult to know how a meter will react to a contrasty situation, the best solution is to use a hand-held spot meter, or the spot meter function of an in-camera meter, to read that portion of the composition that represents medium gray. Use that reading for the shot.

For the early morning shot I took my spot reading from the middle tonal band that forms the center ridge line in the image. All the other tones in the picture fell into place.

TECHNICAL DATA: Sunrise—Mamiya RZ 67, 350 APO telephoto lens, 1/15, f/5.6 (exposure determined with Minolta Spot Meter F), Fujichrome Velvia, tripod. Mid-afternoon—1/125, between f/8 and f/11, Fujichrome Velvia, tripod.

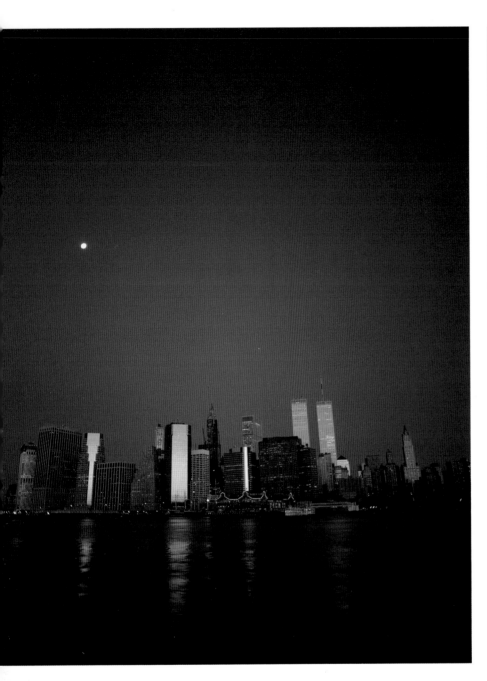

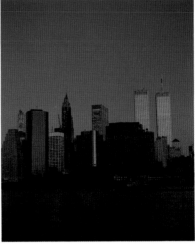

The color and quality of natural light continues to change dramatically throughout the morning, as shown in this sequence of shots of the New York City skyline.

At dawn, the sky retains the purplish hues of night while the mirrored skyscrapers begin to reflect the yellow glow in the eastern sky behind the camera's position as shown in the image on the left. When the sun first breaks the horizon, as shown above, the sky's color changes to blue, while the buildings are illuminated directly by the low-angled golden light. An hour-and-a-half after sunrise (opposite, left) the city is front lit by a higher sun that still retains a little of the warm tones of early morning. Finally, the shot (opposite, right) which was taken from the top of a nearby building at about 10:30 A.M. shows New York fully illuminated by daylight.

TECHNICAL DATA: Dawn—Mamiya RZ 67, 50mm wide angle lens, 1/8, f/4.5, Ektachrome 64, tripod; Sunrise—Mamiya RZ 67, 180mm telephoto lens, 1/30, f/4.5, Ektachrome 64, tripod; Early Morning—Mamiya RZ 67, 50mm wide angle lens, 1/125, f/8; Ektachrome 64, hand-held; 10:30 A.M.—Mamiya RZ 67, 127mm normal lens, 1/250, f/5.6-f/8, Ektachrome 64, hand-held.

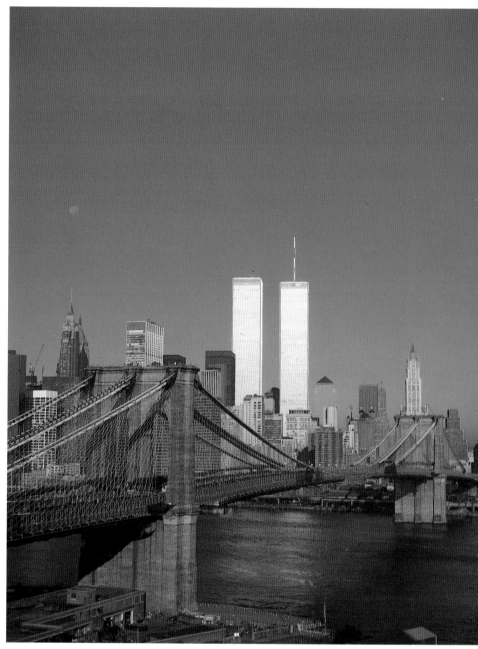

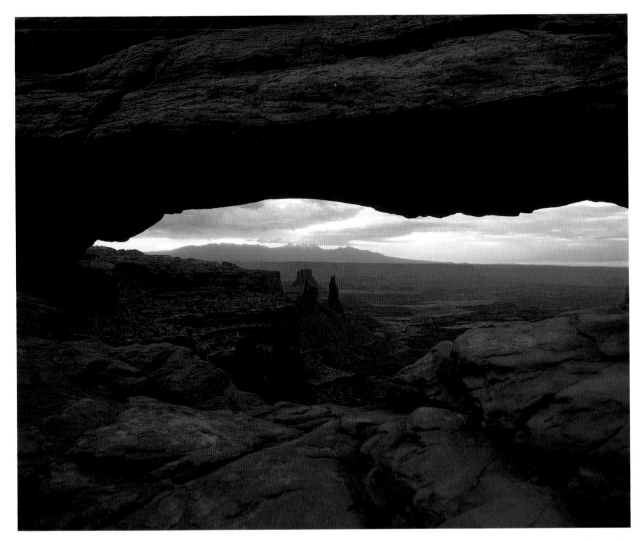

Often two photographs of the same location can appear dramatically different even when taken only forty-five minutes apart as seen in these shots of Mesa Arch in Canyonlands National Park, a famous location for sunrise shots. At dawn, when the color temperature is high (about 12,000 degrees Kelvin), the scene is rendered in deep blue and purple tones. This shot was not filtered; the color is solely the result of how film reacts to the diffused, ambient light characteristic of dawn. (See page 53 for more on color temperature.)

As soon as the sun breaks the horizon, the whole scene changes dramatically. The color temperature drops immediately from 12,000 degrees Kelvin to perhaps 3,500 degrees Kelvin, bathing the landscape in a warm light. The underside of the arch reflects the golden sunlight, and Washer Woman Arch—the distant land form in the center of the photo—is silhouetted against the backlit haze behind it. Note how the low-angled light on the rocks creates a texture in the foreground that contrasts the darker portions of the composition.

TECHNICAL DATA: My meter readings for the two morning pictures were determined with a Minolta Spot Meter F. I took the reading from a mid-tone area of the frame. Dawn—Mamiya RZ 67, 50mm wide angle lens, Fujichrome Velvia, tripod. I placed the spot meter's sensor on the narrow band of distant mountains and got two seconds at f/16. Sunrise—Mamiya RZ 67, 50mm wide angle lens, Fujichrome Velvia, tripod. I used the glowing underside of Mesa Arch for medium gray with an exposure of ¼ second at f/16.

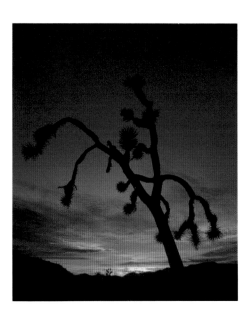

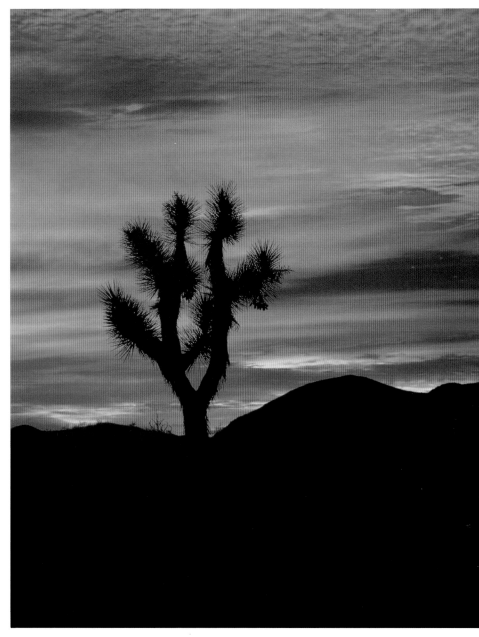

One of the most challenging aspects of shooting at dawn is finding good compositions in the dim light. It usually takes quite a while to establish a workable shooting position, but by the time you study the landscape, the conditions in the sky have begun to change rapidly. It can be quite frustrating to watch the sky deepen with intense color when you still haven't found a suitable foreground. Scouting an area in advance will save you from stumbling around in the dark, hoping to find compositions as you race against the clock.

If possible, scout sunrise locations the day before you plan to shoot. Look for dramatic land forms, graphic trees or vegetation that will glow with backlighting or for a city skyline that, combined with the beautiful colors in the sky, will make a stunning shot. There is no shortcut for finding these photogenic scenes. You simply have to invest the time before you start shooting. You'll have to use a little imagination, because the lighting will be totally different at dawn than when you're scouting. But you can still look for strong graphic shapes in trees, rocks and other subjects that will look good silhouetted against a beautiful dawn or sunrise sky.

Keep in mind the extreme contrast between the sky and ground at dawn. Film latitude is limited. Using only natural light (no fill flash, split neutral density filters, or

computer manipulation) you can properly expose the highlights or the shadows—but not both. This means that compositional elements below the horizon will be rendered black, or at least very dark, when you expose for the sky.

Note how little detail of the Joshua tree silhouetted against the brilliant orange sunrise you can see in the photo above. I could distinguish detail in the bottom of the tree, but the film, because of its relatively narrow latitude, could not. Latitude is the ability of film to render both highlights and shadows

properly exposed. (For more on film latitude see page 75.) Compare that image with the one above, left, where the horizon was lower. This time I could compose a shot that shows more detail of the whole tree against the dawn sky.

TECHNICAL DATA: Tree with orange sky—Mamiya RZ 67, 250mm telephoto lens, ¼ second, f/5.6, Fujichrome 50D, tripod. Full tree silhouette—Mamiya RZ 67, 50mm wide angle lens, ½ second, f/5.6, Fujichrome Velvia, tripod.

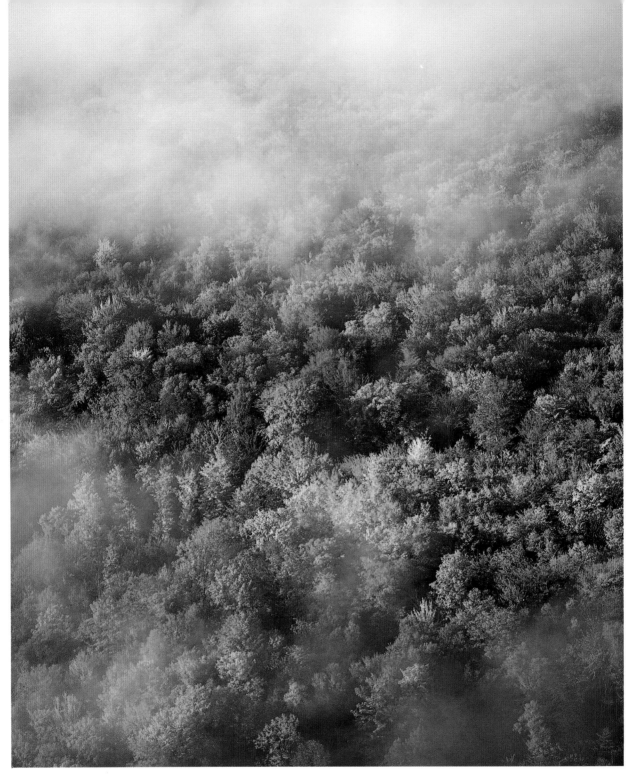

Early morning photographs can include fog or dense clouds clinging to the ground. The play of light that often occurs with this natural phenomenon can be quite beautiful. Or the low clouds can act as a frame through which the subject can be viewed. This unusual aerial view of autumn foliage through low hanging clouds was taken from the top of Owl's Head Lookout in the northern part of Vermont.

Although I took this shot about a half-hour after sunrise, the low-angled sunlight is still providing strong side lighting. In addition, the low clouds that had condensed from water vapor overnight were still in evidence. (Within twenty minutes they were gone.) From my high vantage point about two thousand feet above the forest, I could see the brilliant color created by the trees through a break in the clouds.

A large white expanse in the composition can trick your camera's meter into a wrong exposure. The bright portion of the frame signals the electronic meter to reduce the exposure in an attempt to make the white clouds medium gray—what the meter is programmed to do. This would result in an underexposed image. To avoid this problem, take the meter reading from the colored trees, not from the clouds, as I did here.

TECHNICAL DATA: Mamiya RZ 67, 350 APO telephoto lens, 1/125, f/5.6, Fujichrome Velvia, tripod.

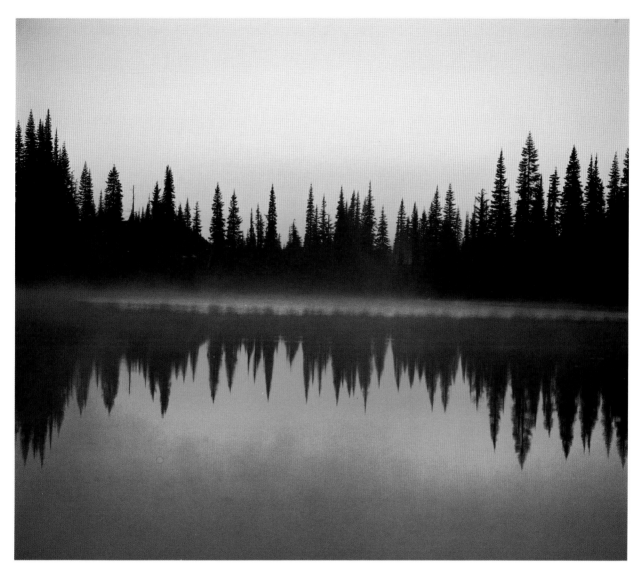

Because changes in the light make the landscape appear so different before and after the sun breaks the horizon, you will need to keep taking meter readings while you shoot. These two photos of Reflection Pond in Mt. Rainier National Park, Washington, are examples of the difference a few minutes can make. Both the reading and the way you read the light will change.

The shot above is full of subtle tones and directionless light. Note the perfect mirror reflection in the pond, a benefit of shooting water before sunrise. Because the wind usually doesn't start to blow with any force until the sun shows itself and begins to heat the air, there are no ripples in the water to disturb the reflection.

Ten minutes after sunrise, the pond (right, photographed from a slightly different angle) is brilliantly lit with golden shafts of sunlight streaming through the mist, laying long shadows across the water.

The reflection is just beginning to break up as the air begins moving in response to the warmth of the sun.

Because the conditions changed greatly between the two shots, I used different methods to read the light. I used a hand-held incident meter to determine the exposure for the dawn photograph above, because I didn't see any middle-toned part of the picture to read with a spot meter. The high-key sunrise shot on the right was read with a spot meter. I placed the narrow, angled spot in the center of the trees across the water, making that portion of the picture a medium gray value. I knew that having the middle-toned area of frame rendered correctly in an image meant that the highlights and shadows would fall into place as they look to the human eye. Letting highlights or shadows affect a meter reading will cause an underexposure with the former and an overexposure with the latter.

TECHNICAL DATA: Dawn—Mamiya RZ 67, 250mm telephoto, 1/8, f/4.5, Fujichrome 50D, tripod. Sunrise—Mamiya RZ 67, 250mm telephoto, 1/125, f/8, Fujichrome 50D, tripod.

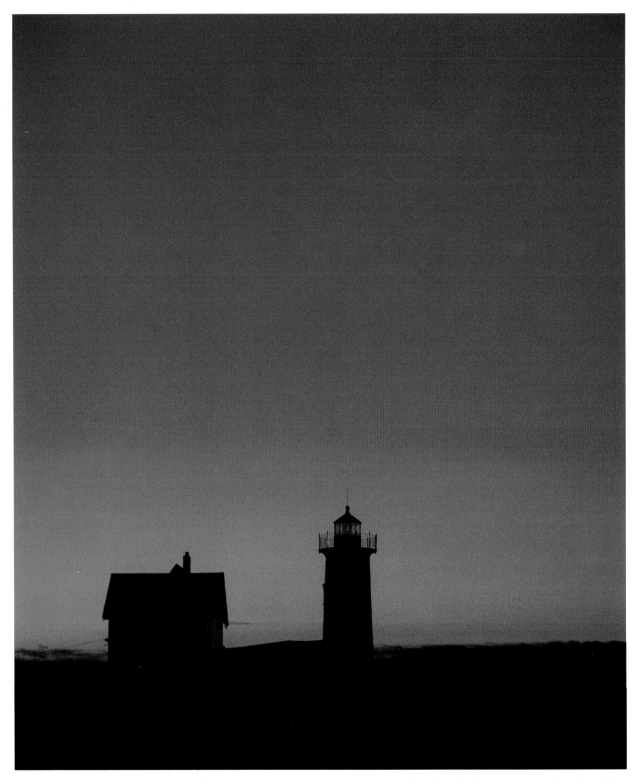

To determine the exposure for this shot of Nubble Light on the coast of Maine, I took a spot reading on the demarcation between the orange and the blue regions of the sky. I knew that a reading only on the blue—the very dark portion of the frame—would result in an overexposure. A reading only on the bright orange—the lightest portion of the frame—would produce an underexposure. Therefore, I selected the transition line to equal a tonal value of medium gray, and made the exposure. For the shot above, I used a long exposure so the red, rotating light could be captured on film.

TECHNICAL DATA: Mamiya RZ 67, 250mm lens, 2 second exposure, f/4.5, Fujichrome 50D, tripod.

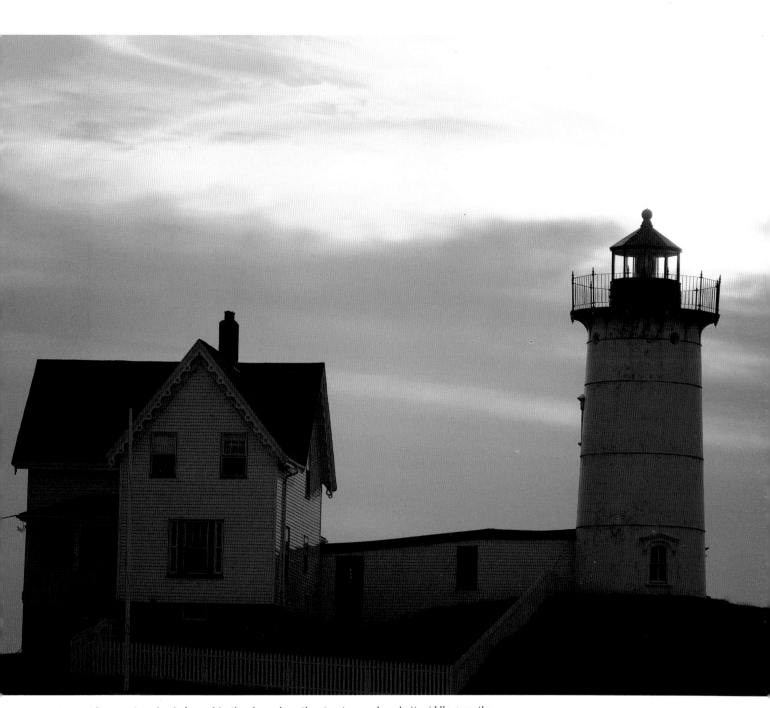

After sunrise, clouds formed in the sky and created a softer, less dramatic illumination. This partial silhouette was an exposure compromise between the highlights in the sky and the darker tones on the lighthouse. I took the light reading with a spot meter, placing the sensor on a middle-toned portion of the gray clouds. Had I exposed for the structure and made it middle gray, the sky would have been totally washed out. Note that the paint on the building is white, but it appears a couple of f/stops darker than the middle gray.

TECHNICAL DATA: Mamiya RZ 67, 500mm APO telephoto, 1/30, f/6, Fujichrome 50D, tripod.

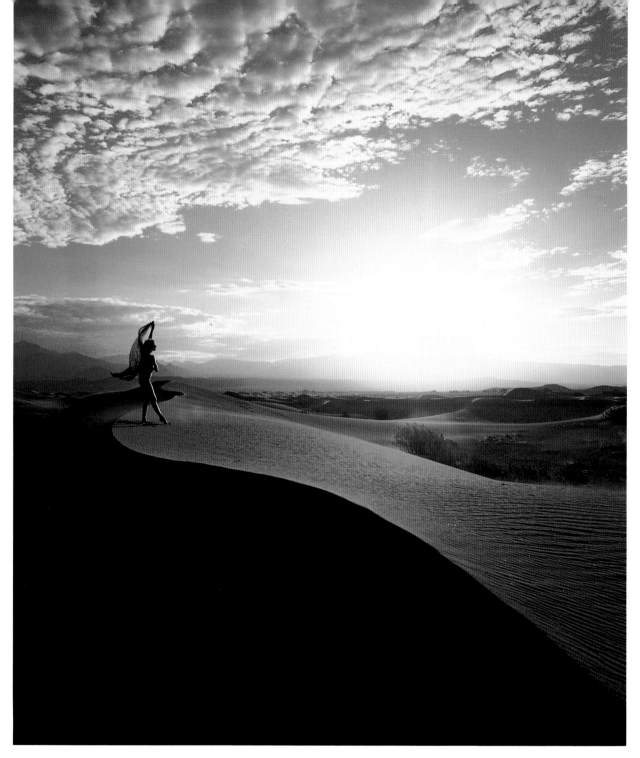

Low-angled light is far more effective for creating sensational images in nature than light coming from above the subject because it gives your images much richer texture, more clearly defined shadows and warmer colors.

In this picture, taken on the famous sand dunes in Death Valley, California, the ripples in the sand show up well on film because of the light skimming across the sand. Depressions in the sand show up as shadows; raised areas catch the sunlight and are revealed as highlights. The glare on the sand caused by the low angle of the light also enhances the visual texture.

The shadows tend to go black when you expose for the highlights, as I've done here, and the contrast between the deep, strongly defined shadows and the illuminated portions of the sand is dramatic. The graceful S curve in the crest of the dune marking the line between sunlight and shadow provides a strong graphic element to draw the viewer's eye to the juxtaposition of light and dark.

Although the colors here are quite warm, the yellowish hue of sunrise is not as pronounced as it was thirty minutes before I took the shot. By this time the intense yellows characteristic of sunrise had been lost, partly due to the time elapsed and partly due to the thin clouds filtering the light in the east. This is a successful image, but I do prefer the even warmer tones of early light.

TECHNICAL DATA: Mamiya RZ 67, 50mm wide angle, 1/125, f/4.5, Fujichrome 50D, tripod.

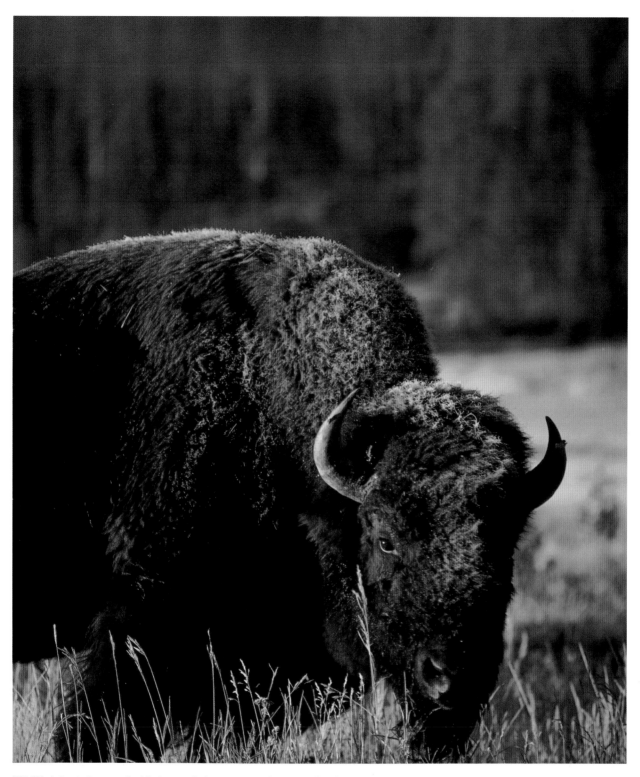

Wildlife is best photographed in low-angled light. In addition to the beautiful golden hues and rich texture of a sunrise, the low-angled light provides a catchlight (sometimes referred to as "eyeshine") in the eyes of your subjects. Dark brown eyes buried in dark hair can be hard to distinguish, so a highlight in the eye can make or break a picture. Instead of the harsh, black shadows cast by an overhead sun, you get soft illumination of dark fur and hair for a more appealing picture.

This tight shot of a bison was taken in Yellowstone National Park in early autumn. Note the frost on the animal, which can only be seen for about twenty minutes in the early sunlight. After that time, it's warm enough for the frost to melt.

Shooting in the early morning also means that you have a better chance to observe and photograph interesting animal behavior and poses because animals are more active in the first part of the day.

TECHNICAL DATA: Mamiya RZ 67, 250mm telephoto lens, 1/125, f/5.6, Fujichrome 50D, tripod.

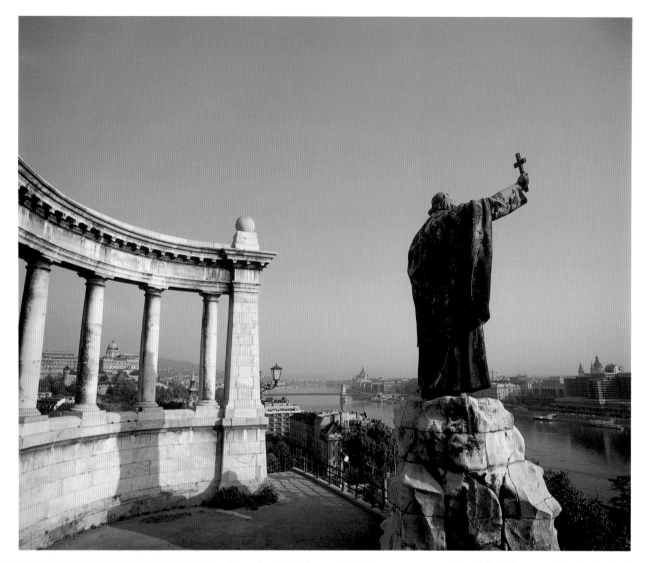

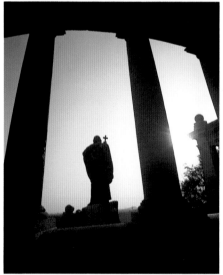

When shooting in low-angled light, you can choose among front, side and back lighting, each of which produces different images. Which lighting method you use for a particular subject will be determined by the relationship between you, the subject and the sun, and the effect you want to achieve on film. Change positions between shots or several times before shooting and watch what happens to the illuminated subject as your vantage point changes. Doing so will expand the creative opportunities you'll find in each scene you photograph.

These two photos of the famous St. Gellert's Memorial in Budapest, Hungary, illustrate the impact that changing the direction of the light can make. In the horizontal composition, warm frontal lighting is attractive on the columns while the statue is side lit. Also note how blue the sky is. I then moved around the statue, looking for another shot, stopping about twenty-five feet from where I took the first one. In this second frame, taken only a couple of minutes later, the backlit memorial is now a dramatic silhouette against a very bright sky.

TECHNICAL DATA: Horizontal: Mamiya RZ 67, 50mm lens, 1/125, f/5.6, Fujichrome Velvia, tripod. Vertical: Mamiya RZ 67, 50mm lens, 1/125, f/5.6-f/8, Fujichrome Velvia, tripod.

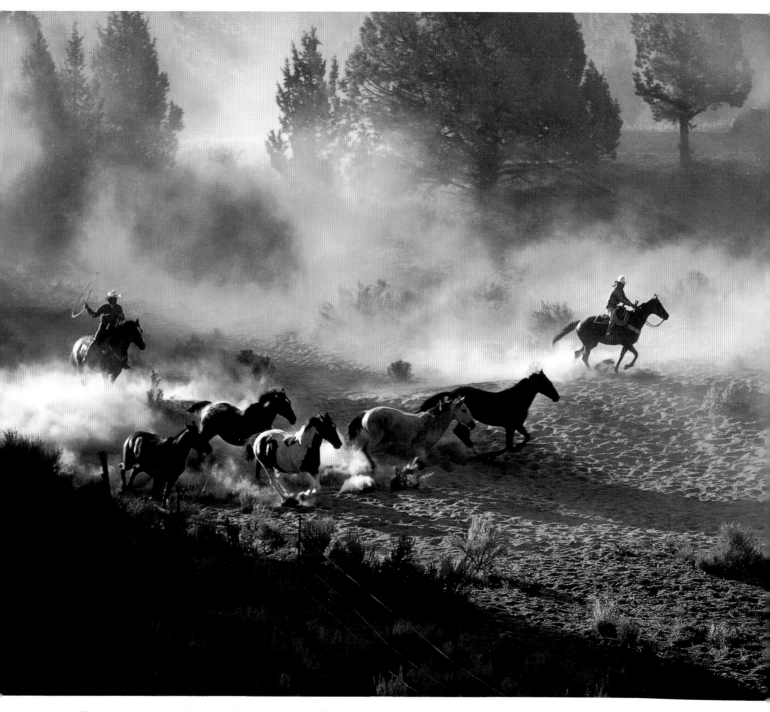

Three elements make this an exciting picture: action, dust and lighting, but the lighting is perhaps the most important. Had this shot been taken at midday, the action and the dust wouldn't have had the same impact. The something extra here is the magical quality of early morning light, which gives the sand its rich texture and makes the dust in the air seem to glow.

I took this picture about a half-hour after sunrise near Bend, Oregon. You can't shoot much later than that and capture the same light quality, although you can still get some good images. (The next time of day when the same effects are possible is sunset.)

Notice that the various elements in the frame receive different lighting: some are sidelit, some partially silhouetted and some have rim lighting.

TECHNICAL DATA: Mamiya RZ 67, 250mm telephoto, 1/250, f/4.5, Fujichrome 100D, tripod.

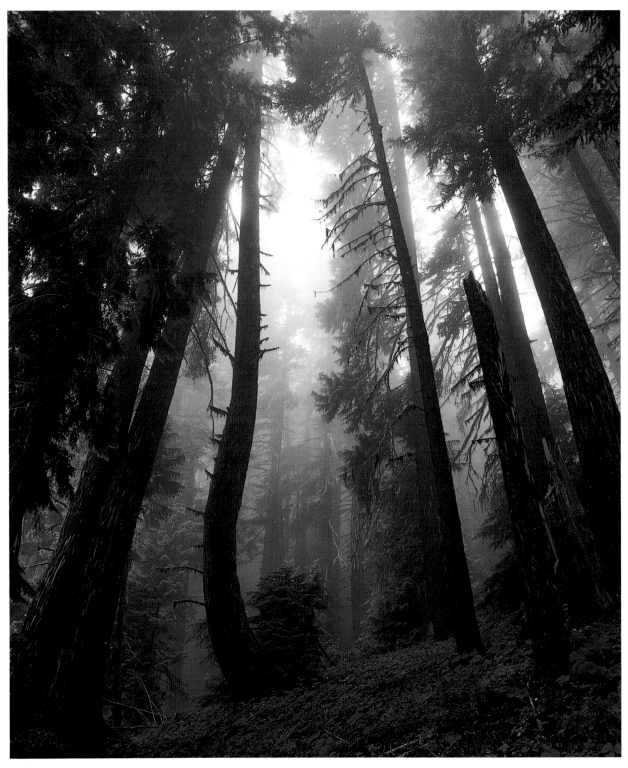

The Pacific Northwest is an example of an area where conditions are perfect for early morning fog—near the ocean in the summer and inland in the winter. If you are anywhere from San Francisco to Seattle and points north, you can expect to find classic images of dense fog shrouding forests, mountain ranges, bodies of water and cityscapes. I discovered this majestic forest scene in July just twenty feet off the road on Hurricane Ride near Port Angeles, Wash-ington. The very dense fog transformed a beautiful forest into a magical one.

Although we think of fog as reducing light and dampening colors, your camera meter sees fog itself as a bright, white area. In this image, for example, the fog is so much brighter than the subtle tones of the greenery that the camera's meter could give an inaccurate reading, causing the picture to be underexposed. You will get an accu-rate exposure by pointing the camera only at the green foliage, take a light reading, and use that to make the final exposure. You can use a telephoto lens to crop out the foggy portions of the composition, then switch to a wide angle lens to make the shot. You can also use a hand-held spot me-ter to read a medium-toned green branch to get an accurate reading, as I did here.

TECHNICAL DATA: Mamiya RZ 67, 50mm wide angle lens, 1/8, f/11, Fujichrome 50D, tripod.

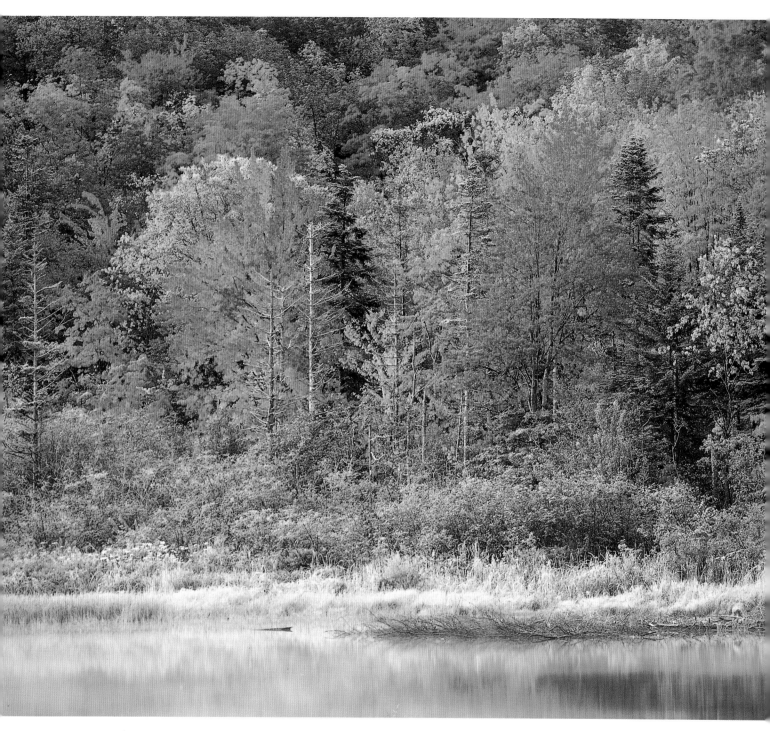

Frost is characteristic of early morning photography in autumn and winter. There is a beautiful contrast between the whiteness of the frost and the bright colors of the surrounding foliage before the sun melts the delicate ice crystals. (In the early dawn light, frost can also often have a bluish tint.) As the glow in the eastern sky intensifies, the ambient light warms up a bit, neutralizing the whiteness of the frost. Then

it's gone. On this day, the frost vanished only twenty minutes after the sunlight began to hit it.

I took this shot in central Vermont during late September. The sunlight had already reached the upper portions of the hill (about two hundred feet above the frost line), providing a slightly warm cast to the trees below without actually illuminating them directly. When I made the exposure,

I avoided pointing the meter at the frosted grass and bushes because the whiteness could adversely affect the reading. Instead, I pointed the meter at the multi-colored forest, which would approximate a medium gray.

TECHNICAL DATA: Mamiya RZ 67, 350 APO telephoto lens, 1/60, f/5.6, Fujichrome Velvia, tripod.

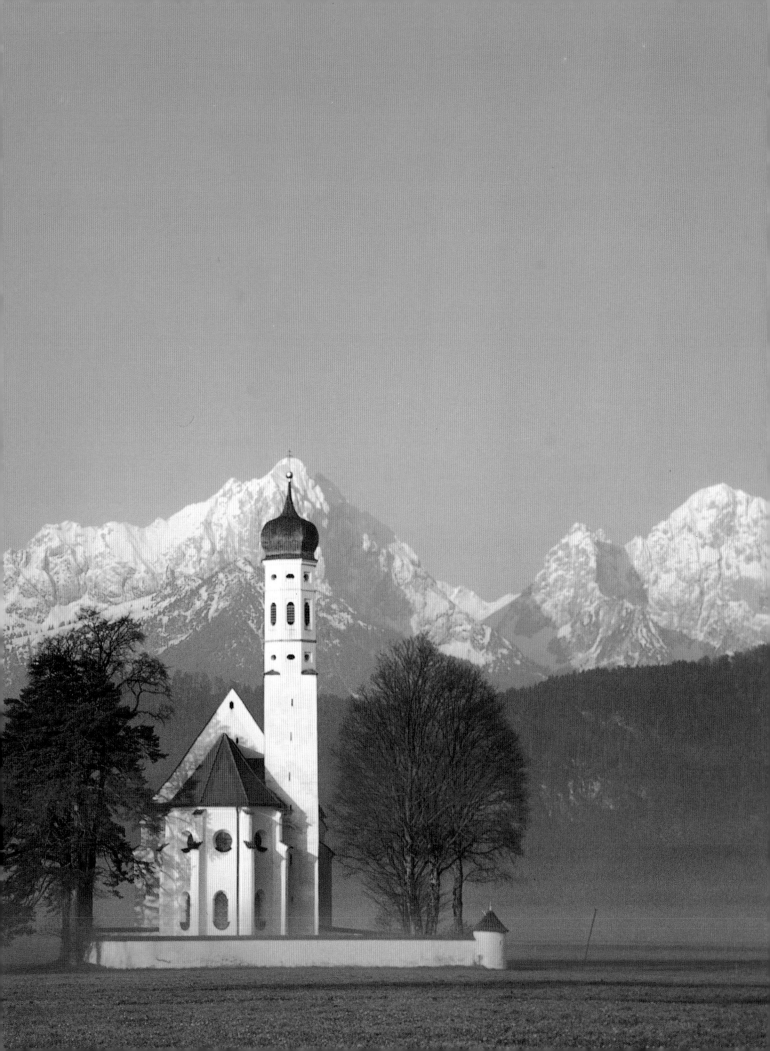

Early Morning/ Late Afternoon

Photography during the early morning and late afternoon offers many of the characteristics of sunrise and sunset. The light has a warmth to it; the angle of light is relatively low; textures are still pronounced; and you can use the sun for front, side or back lighting. At these times of day, however, you can shoot at a more leisurely pace, instead of racing against the clock to capture those brief, few minutes of sweet light. The higher angled sun can penetrate deep canyons protected by sheer cliffs or city streets flanked by tall buildings. When the sun is close to the horizon, it leaves these types of locations in shadow.

It's a little easier to obtain accurate exposures in the early morning or late afternoon. The extreme contrast when shooting into a rising or setting sun against a dark landscape makes any photographer nervous about proper exposure. Most of your shooting with a higher sun won't entail that kind of extreme light ratio. But there are still careful choices to be made. Every time you take a picture, you must select the shutter speed and the size of the lens opening.

The first consideration is shutter speed. If you are hand-holding the camera and want a sharp picture, then you can't use a shutter speed slower than 1/60. Only use 1/60 if light conditions require it. Sharpness will be retained only when shooting at 1/125 or faster. If you are using a 35mm camera with a 300mm or longer range telephoto lens without a tripod, then a shutter speed of 1/250 or 1/500 is preferable.

You can use any shutter speed when you use a tripod. Most of my long exposures of nature subjects range from ¼ second to two full seconds. A long exposure only becomes problematic when your subject—a leaf or a flower, for example—can be moved by the wind. In these situations, you must either wait for a lull or use a faster shutter speed (or a flash).

You must also choose a lens aperture. This is significant because depth of field (how much is in focus in front of and behind the subject) is intimately connected to the size of the aperture. The larger the lens opening, the less depth of field. As the lens opening decreases, the depth of field increases. Sometimes a limited depth of field is desirable; at other times, extensive depth of field is the best artistic choice.

For example, a sharp background to a wildlife portrait may be distracting. The animal must compete for the viewer's attention. Using a large lens aperture, such as f/2.8, f/4 or f/5.6, causes the background to become a soft blur while the face of the subject remains sharp. On the other hand, photos of landscapes and architecture usually are more appealing when the foreground and background are sharp. Apertures ranging between f/16 and f/22 will let you achieve this, especially when you use a wide angle lens which provides more depth of field than telephotos.

Depth of field is also dependent on whether you use a tripod. It is easy to become lazy and not carry one. But without this steady camera support, you can't use long shutter speeds and, therefore, can't use small apertures in low light situations. Even in bright sun you won't be able to hand-hold the camera and shoot a fine-grained film such as Fujichrome Velvia at f/16 or f/22. Under a dense cloud cover with low light levels, or when shooting at dawn or dusk, a tripod is essential. Without one, you can only shoot fast film at the largest aperture available and won't have the luxury of using depth of field to enhance your photographs.

As long as you're going to spend the money, time and energy on serious photography, you might as well do it right. Use the tools that are available to make the most impressive images possible.

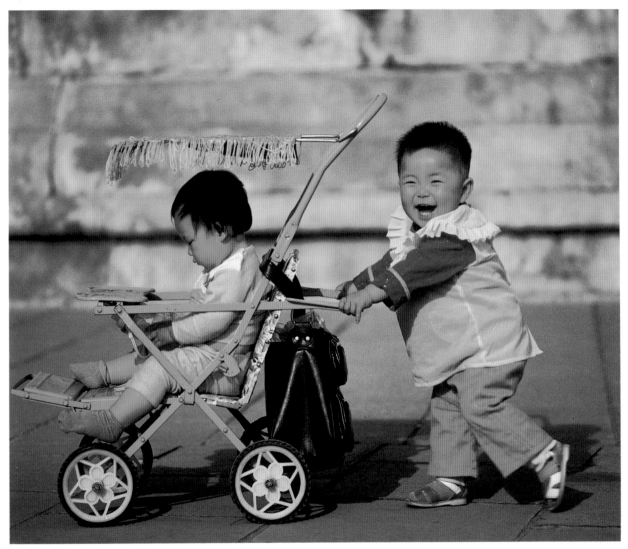

Study the shadows behind the two children in this picture. They show from which direction the sun is coming: behind the camera position. The low, front lighting fills any unwanted shadows of the children's faces and prevents anything from interfering with the wonderful expressions and body language. An incident meter read the light falling on the scene.

This picture was taken about 4:00 P.M., the hour that I use as a demarcation between harsh, midday light and the softer, warmer light of the late afternoon. Can you take acceptable photos at 3:30? Of course. But all other conditions being equal in the summer for temperate regions, 4:00 P.M. is better, and 4:30 is better still. Every minute the sun sinks closer to the horizon means that the color of the light increasingly warms up, approaching the golden tones of sunset. In addition, the contrast between light and dark diminishes and the shadows lengthen, increasing the dimension of objects.

As the season changes, so does the light. In winter, the sun sets earlier, so 3:00 P.M. becomes my demarcation time in a temperate zone. Light also changes as you travel north and south across the earth. In the far North and South, such as Alaska and southern Argentina, good lighting for photography varies greatly depending on the latitude and the season.

TECHNICAL DATA: Mamiya RB 67, 180mm lens, 1/125, f/5.6, Ektachrome 64, Minolta Flash Meter III, hand-held.

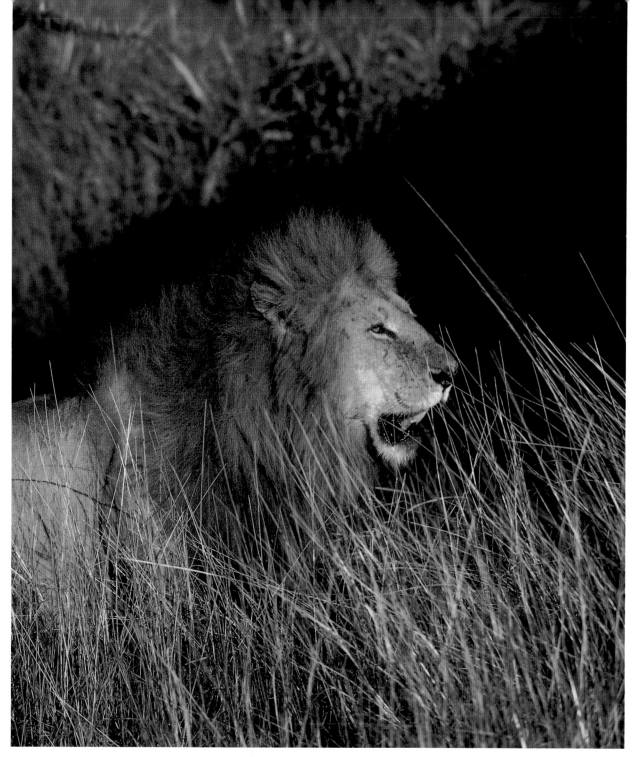

Even after the magic of the light at sunrise has changed into the characteristic hues of daylight, you can continue to make striking photographs. This profile of an African lion in the Maasai Mara of Kenya was taken about ninety minutes after sunrise, when the sun was about twenty degrees above the horizon. The light still has a tinge of yellow in it, and the direction from which the light is striking the cat is low, though the angle is not as low as sunrise.

The dramatic contrast between the illu-minated lion and the dark shadow behind him makes this picture exceptional. The early morning sun, still relatively low in the sky, created the dark shadow, which makes the lion virtually pop out of the background.

Had this image been taken near noon, when the sun would be directly overhead, the tree just outside the frame would not have cast the shadow.

The side lit mane also makes this image more dramatic. Although the cat's face is front lit, the side lighting on the portion of mane toward the camera brings out the rich texture of the mane. If the lighting were flat, it would not create the highlights and shadows in the mane that here define the regal quality of the king of beasts.

TECHNICAL DATA: Mamiya RZ 67, 350mm APO telephoto, 1/250, f/5.6, Fuji-chrome Provia 100. The camera was sup-ported by a beanbag placed on the vehicle's door frame.

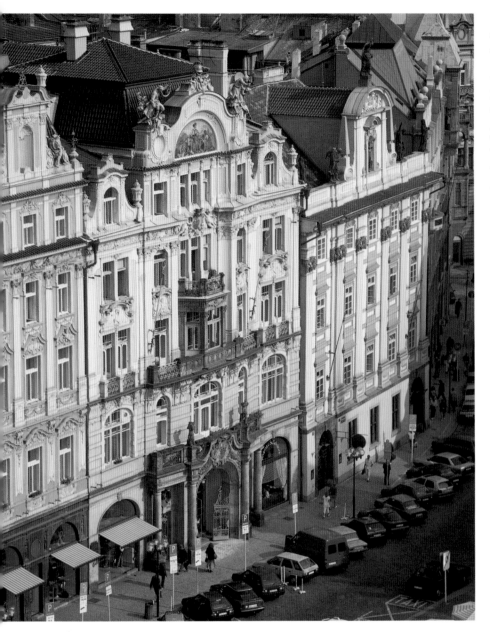

Some locations are impossible to shoot at sunrise and sunset. Deep canyons are often surrounded by sheer cliffs that don't allow the low-angled sunlight to reach the bottom. Cities can present the same challenges. Multi-story buildings act like vertical canyon walls, blocking the beautiful golden light from reaching the streets. Only when the sun rises high enough above the buildings—say, around 9:00 or 10:00 A.M.—will it illuminate architectural facades and street scenes. Midday, overhead sunlight is usually too harsh for good photography in cities, but in the afternoon—perhaps about 3:00 or 4:00 P.M.—the angle of the sun will provide attractive light that can still penetrate to street level. City scenes can be photographed at twilight, of course, when direct sunlight is no longer an issue, or from an aerial perspective when the sun is low.

This photo of the old town center in Prague, the Czech Republic, was taken about 8:45 A.M. I was shooting from the clock tower just after the sun rose above a church that had been casting a shadow across the facade of the buildings. The early morning sun still had enough of a golden tone to enhance the rich colors of the buildings. The light was also still soft enough to bring out the detailing on the facades. I was lucky here that the shadow disappeared before the beautiful qualities of early morning light were gone.

I consider early morning light, as opposed to sunrise light, begins about an hour after the first rays of the sun are seen on the landscape or cityscape. On or near the equator, however, the golden tones of sunrise are virtually gone in thirty minutes. In the extreme northern and southern parts of the globe, low angled, golden light lasts for two or three hours. Early morning light, in that case, would begin considerably later than in temperate North America, Europe and Asia.

TECHNICAL DATA: Mamiya RZ 67, 350mm APO telephoto, 1/125, f/5.6, Fujichrome Velvia, tripod.

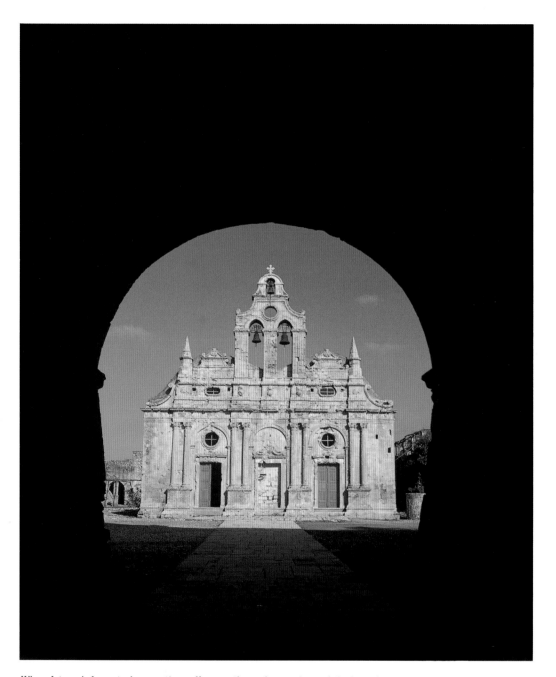

When I travel, I must plan my time effectively to squeeze the maximum amount of excellent photography out of a day. I often know ahead of time what I'll be shooting, but will still need to determine the east-west orientation of the subject to discover the best time of day for shots. A subject that faces west will be front lit in late afternoon, while one that faces east will receive front lighting in early morning.

If a building or monument has a dramatic graphic shape—the Eiffel Tower or the New York City skyline, for example—that will work both in silhouette as well as with front lighting, I might visit it both in the early morning and the late afternoon to get two different interpretations. Subjects facing South, such as the faces carved into Mt. Rushmore, can also be photographed both early and late. In fact, during the winter months when the sun is low, most subjects will look good even at midday. Subjects facing North are in the shade and can be photographed at any time provided a bright background, such as the sky, doesn't detract from the darker subject.

The Monastery of Arkadi on the island of Crete faces West, so the best time of day to shoot is late afternoon. I used the dark arch of a passageway to frame the monas-tery. When I exposed for the ancient edifice, which was several stops brighter than the passageway, the limited latitude of the film turned the arch into a black shape. I could see plenty of detail in the arch even with the subdued light, but the Fujichrome film couldn't hold detail in the dark area. Had I exposed for the arch instead of the building, the monastery would have been grossly overexposed.

TECHNICAL DATA: Mamiya RZ 67, 50mm wide angle, 1/15, f/22, Fujichrome Velvia, tripod.

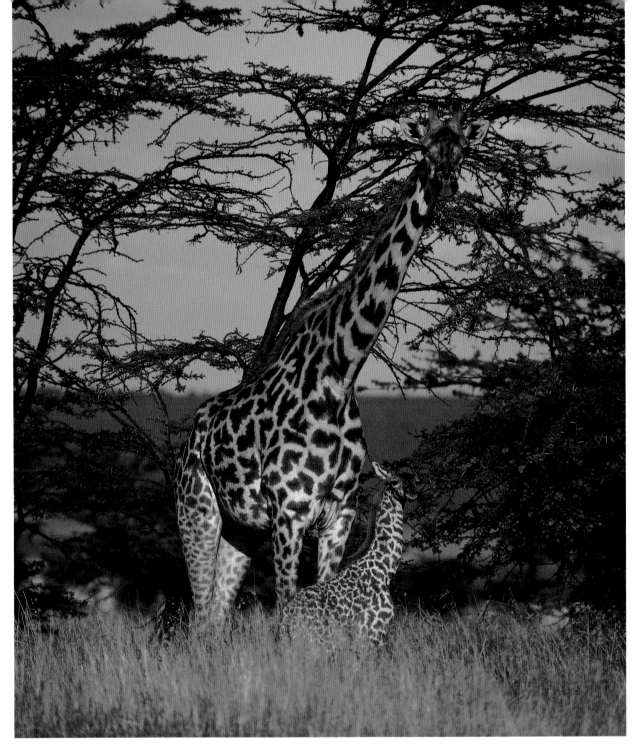

When it comes to lighting, photographing wildlife is very similar to shooting people. If the sun is overhead, you will have unattractive shadows on both human and animal subjects. As the sun moves toward its zenith, you will also discover the catchlight in the eyes is lost, and the color of the iris is hidden by the shadow of the eyebrow.

When I was on safari in Kenya, I rested during the middle of the day and shot virtually all my photographs in the early morning and late afternoon. I'd leave the tented camp at 3:00 or 3:30 P.M. every day to look for game. The light was good from 4:00 P.M. until sunset, which occurred at about 6:15 P.M. This left me only two hours to shoot, but I would only have wasted my film if I had started before the light was beautiful.

This Maasai giraffe and its one-week-old baby were photographed about 4:00 P.M. in the Maasai Mara Game Reserve. The doting mother allowed the vehicle to approach within easy telephoto range, but I was still about one hundred feet away when I made the shot. My incident meter determined the exposure by measuring the light falling on the scene. I used the largest lens aperture to gather all the light possible, so I could use a fast enough shutter speed to freeze any movement by the giraffes.

TECHNICAL DATA: Mamiya RZ 67, 350mm APO telephoto, 1/125, f/5.6-f/8, Fuji-chrome Provia 100. The camera was steadied by a beanbag resting on the door frame of the vehicle.

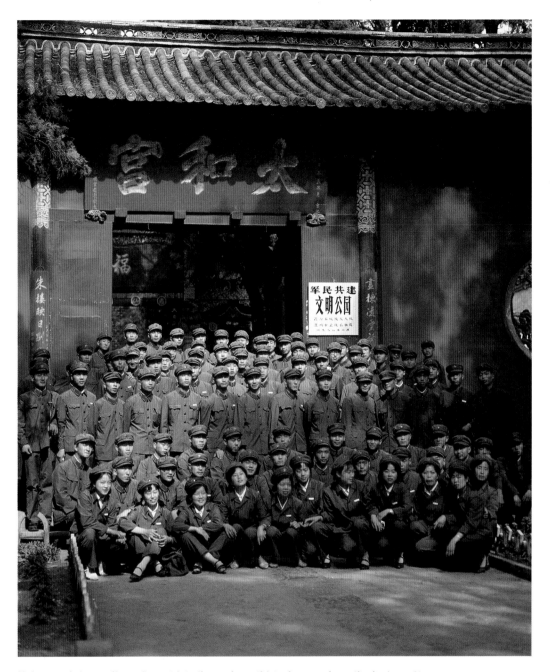

Unless you bring studio equipment into the field to modify the existing conditions, overhead lighting puts harsh, dark shadows under the brow and an unattractive highlight on the nose and cheeks. There are only two ways to photograph people outdoors in available light. You take advantage of the natural softness and the low angle of early morning or late afternoon sunlight, or you find light diffused by cloud cover or a patch of open shade.

I took this image in Kunming, China. While the soldiers were posing for a Chinese Army photographer, I stood off to the side and stole a few frames for myself. It was about 4:00 P.M., and the sun was per-

haps thirty degrees above the horizon. At that time of day, the low-angled light didn't cause any harsh shadows.

Notice the shadows cast by the trees behind both me and the Chinese photographer. The patchy shadows of the leaves falling on the salmon-colored wall kept it from dominating the picture even though the wall was in full, direct sunlight. I couldn't orchestrate this effect, but I was glad to take advantage of being in the right place at the right time.

TECHNICAL DATA: Mamiya RB 67, 127mm normal lens, 1/125, f/5.6, Ektachrome 64, hand-held.

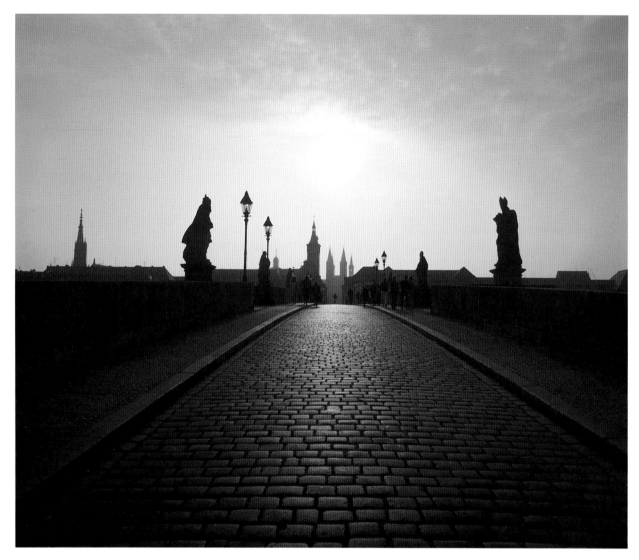

I rarely use color filters anymore, but there are occasions when they can transform an ordinary picture into one with drama and character. This cobblestone bridge in Wurzburg, Germany leads your eye into the center of the medieval town with spires silhouetted against the early morning sky. The sun was weak, however, and the monotone grayness of the partially overcast sky didn't provide an exciting backdrop to the scene.

To rectify the situation, I placed the "sunset" Cokin filter over the wide angle lens I was using. The top half of the filter is tinted dark orange, while the bottom half has a lighter orange tint. The colors of the filter are carefully gradated so there isn't any noticeable line in the picture between the dark and light areas of color. By sliding the filter up and down in its frame, I could alter the effect.

Notice the reflection of the sunlight on the cobblestones. This is not the typical scene where the subject is haloed with rim lighting. Instead, the lighting enhances the brilliant luster of the stones, which is contrasted with the silhouetted figures on the bridge and the shadows between the cobblestones themselves. As the sun rose higher in the sky, the street gradually lost its luster, until it finally disappeared.

I chose a small lens aperture so the foreground stones would be as sharp as the distant city. Therefore, a longer shutter speed was required. My exposure was determined with the hand-held Minolta Flash Meter IV, which reads both ambient light and flash, by pointing its white, hemispherical ball at the sun.

TECHNICAL DATA: Mamiya RZ 67, 50mm wide angle lens, 1/8, f/16, Fujichrome Velvia, tripod.

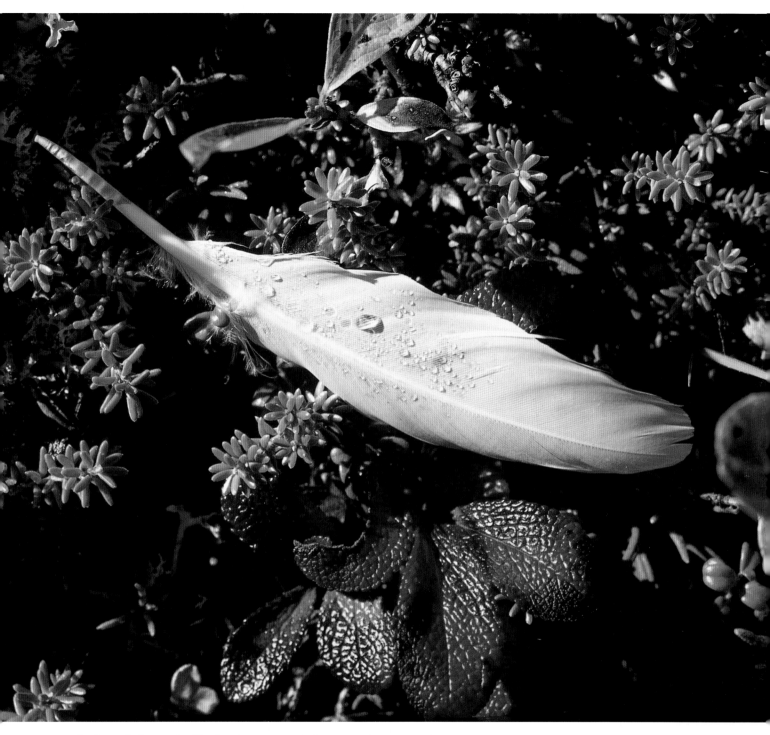

Don't overlook opportunities for close-up photographs inthe early morning or late afternoon. But shooting once the sun is above the horizon poses a major problem that is often absent at dawn and dusk—wind. Since most close-up photography involves small apertures for increased depth of field and long exposures, the wind can make close-ups difficult or impossible to take.

Shooting a couple of hours after dawn or before sunset gives you more light so you can use a faster shutter speed than you can when the sun is closer to the horizon. I placed the feather on the Alaskan tundra so it would not sway back and forth in the wind. If it did blow out of my composition, I simply put it back where it didn't move.

Far north or far south of the equator, the angle of the sun to the earth is always low. Even at noon during mid-summer in Denali National Park, where I took this image, the sun is relatively close to the horizon.

The Mamiya RZ 67 has a built-in bellows system that lets all its lenses focus closely. The feather was large enough that additional extension wasn't necessary.

TECHNICAL DATA: Mamiya RZ 67, 110mm normal lens, 1/30, f/16, Fujichrome Velvia, tripod.

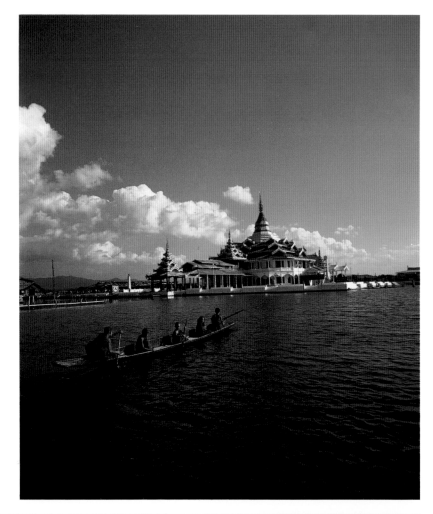

The contrast between light and shadow is much harsher near the equator than in the temperate or Arctic Regions. Tropical countries such as Burma are subjected to a midday sun that is almost directly overhead. Good photography is impossible then, because the shadows are about four f/stops darker than the ambient light.

In the early morning and late afternoon when the sun is low in the sky, however, the light travels through a great deal of atmospheric haze. These airborne particles act as a giant diffusion filter that softens the light considerably, making any scene more attractive. The sunlight falling on these Burmese monks and the temple beyond them is weakened by the haze, and this diffusion imparts a soft quality to the light.

TECHNICAL DATA: Mamiya RZ 67, 50mm lens, 1/125, f/4.5, Fujichrome Velvia, tripod.

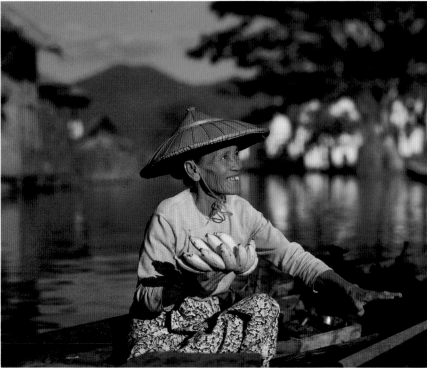

Hats create problems when you're trying to photograph people in natural light. Even a small brim can aggravate the problems caused by working with what can often be overhead lighting. When people wear hats with wide brims, you may not be able to get a good photograph at all because the shadow under the hat darkens the subject's face far below the ambient light. If you take the light reading from the sun, the subject's face is rendered on film as virtually black. In other words, if you take your meter reading from a sunlit portion of the frame to determine the correct exposure, the hat's shadow is so much darker than the ambient daylight that it will appear on the film as a black shadow with no detail.

Because of the problems caused by wide-brimmed hats and overhead lighting, I could only have photographed this woman in the early morning or late afternoon. When the sun is low in the sky, as it was then, the brim doesn't block the illumination from the face. The light striking the subject will be the same intensity as the surroundings. I took this shot about 4:30 P.M., shooting from a low vantage with the sun at my back, as I sat in another boat on Inle Lake in northern Burma near the woman selling her bananas.

TECHNICAL DATA: Mamiya RZ 67, 250mm telephoto lens, 1/125, f/8, Fujichrome 50D, hand-held.

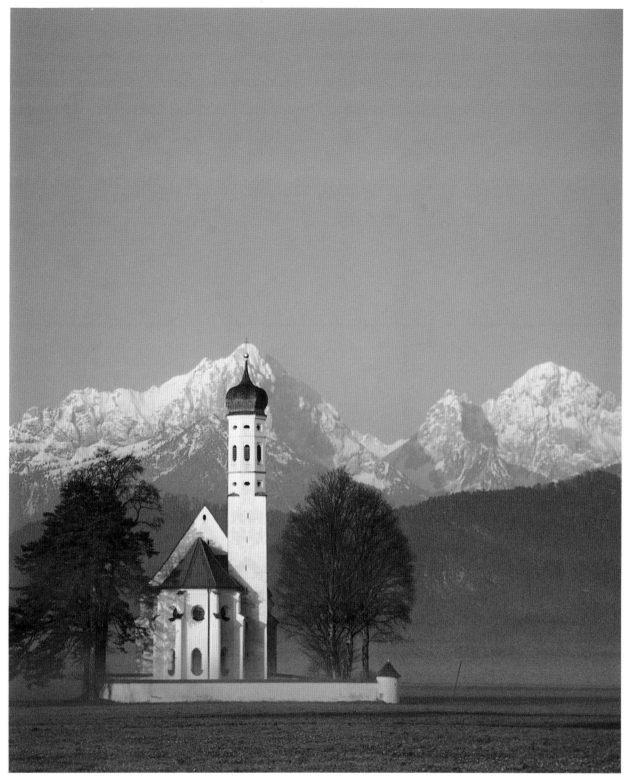

I waited out three days of rain, so I could get this early morning shot of a church in Bavaria. When a morning finally dawned clear and bright, I raced all over the countryside, trying to be everywhere at once to take advantage of the opportunity.

I had to wait about a half-hour after sunrise for the sun to rise high enough to leave its imprint on the land. It's strange to see the ball of the sun just above the horizon without golden light washing over the landscape. Note the color of the light on the church. If this shot had been made in the American Southwest just thirty minutes after sunrise, the light would have been much more yellow. (See the photo of the bison on page 15 or a typical southwestern scene.) The intensity of the light would have been much stronger, and the contrast between highlights and shadows would have been more obvious. Light has different characteristics from what you may have noted in other parts of the world. In a strange locale, observe the quality of the light and discover how best to use it before you take a shot. Your photography will take a quantum leap forward if you do.

TECHNICAL DATA: Mamiya RZ 67, 250mm telephoto lens, 1/8, f/16, Fujichrome Velvia, tripod.

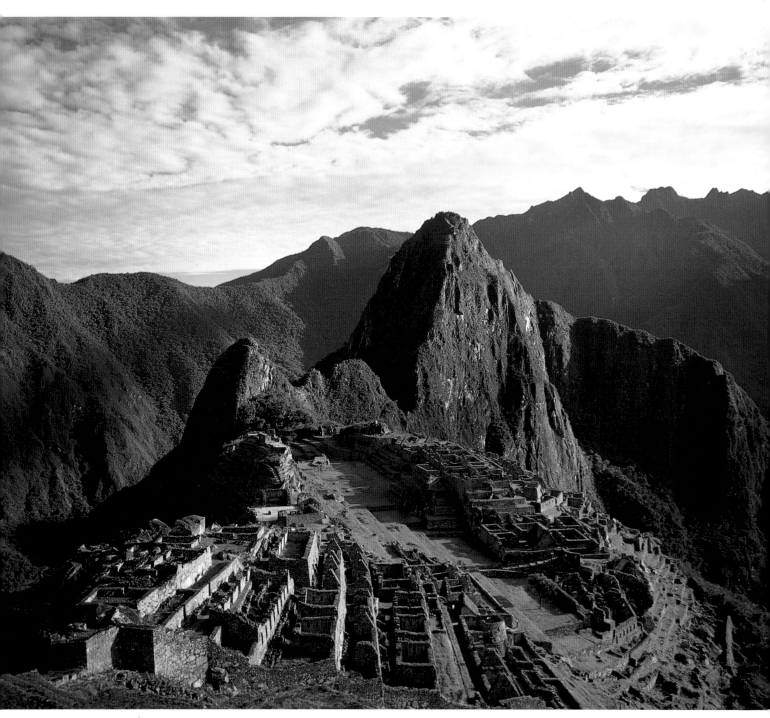

The high peaks that surround the famous Inca ruins of Machu Picchu, nestled in the Andes Mountains of Peru, prevent it from being photographed in golden, low-angled light of sunrise or sunset. By the time the sun rises above the mountains, it is high enough in the sky to cast normal daylight hues on the ancient city. But the light is still beautiful in the early morning.

This shot is characterized primarily by side lighting. The contrast between the sun-lit and shadowed portions of the stone walls and the mountain peaks overlooking the ruins adds a dramatic element to this image. It is true that when an overhead sun illuminates a subject, it also produces a strong contrast between highlights and shadows. However, top lighting is usually not considered as attractive as side lighting.

TECHNICAL DATA: Mamiya RZ 67, 50mm wide angle, 1/125, f/5.6-f/8, Fuji-chrome Velvia, tripod.

It is often difficult to coordinate the timing of my travels with important celebrations in the United States and other countries. If I miss a significant event that I should have in my stock library, I will recreate at least a representation of the affair for the camera.

Recreating an event may produce even better photos than you got during the actual one. Wonderful celebrations can take place under unfavorable conditions for photography. Making special arrangement with local models is your best way to guarantee the type of light you'll have. You'll also have control over the people who are posing for you; you can ask them to position themselves to create exactly the kind of look and composition you want. During a festival, your percentage of usable images goes down because the participants are, predictably, more interested in the event than in helping a photographer.

The costumed flautist pictured here was photographed in Basel, Switzerland during the summer. I had missed the famous annual carnival that takes place in this lovely Swiss town in the early spring. So, I made contact through a local theater group with this young lady who owns three festival costumes and was willing to help me capture the flavor of the event. Since I had made all the arrangements, I could also select the time of day. It would be too difficult to get good shots at sunrise or sunset, since the narrow streets are always in shadow when the sun is low. I chose 10:00 A.M. to begin shooting, working on the assumption that this was enough lead time for the sun to be high enough to illuminate the facade of the old church I wanted to use as a background.

TECHNICAL DATA: Mamiya RZ 67, 250mm telephoto, 1/250, f/5.6, Fujichrome Velvia, tripod.

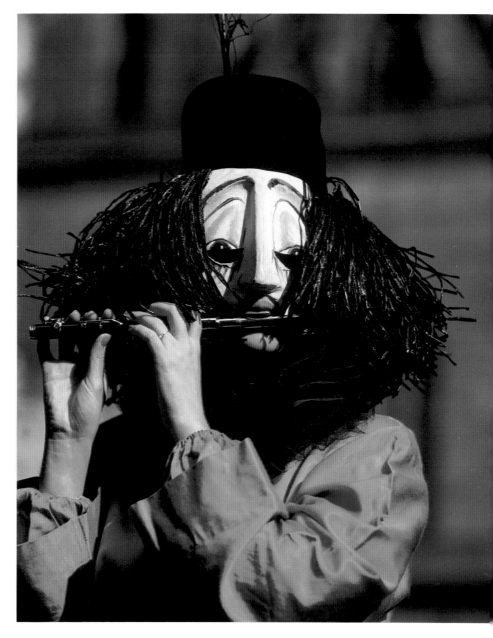

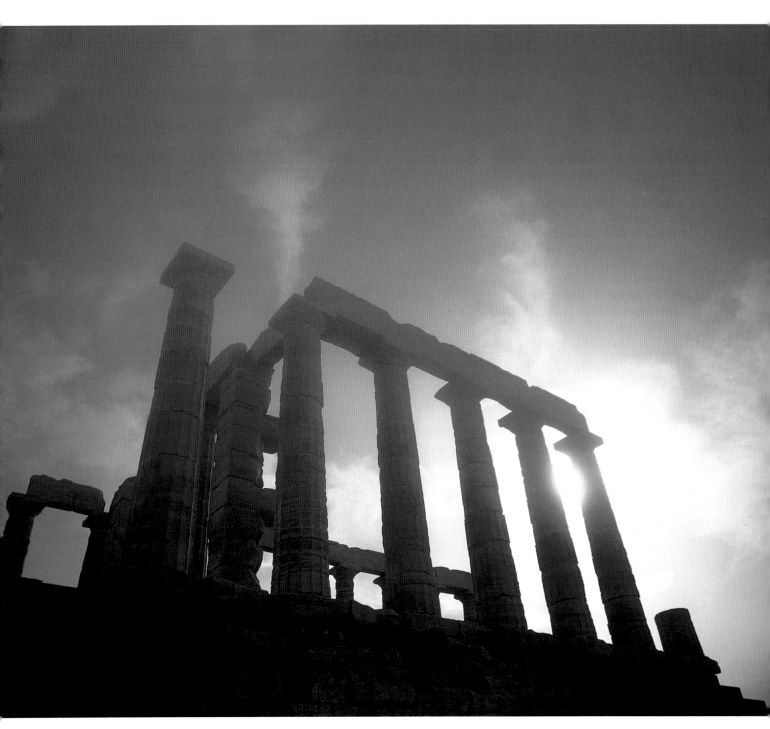

When I was in Greece in 1993, there was so much restoration work in progress on the ancient temples that it was difficult to find one without scaffolding and cranes. Poseidon's Temple at Sounion, which majestically overlooks the Mediterranean, was an exception. It is beautiful at any time of day, but early morning and late afternoon lighting offer more creative possibilities than you find at midday.

You can produce exceptional pictures with your choice of front, back or side light-ing with such a beautifully graphic subject. For this image, I placed the sun behind the structure for a partial silhouette. When shooting into the sun, I usually try to hide it behind an element in the composition, to prevent it from overpowering the overall image and taking attention away from the primary subject. Here, I used one of the columns to partially obscure the sun. A blue Cokin filter altered the color balance to achieve a brooding, moody atmosphere.

In these circumstances, exposures are always determined by reading the sky away from the sun. In other words, exclude the sun from the frame when using your TTL meter to read the light. After you've deter-mined the reading, turn off the automatic exposure feature so it won't override the correct reading, move the camera back to its original composition and take the pic-ture.

TECHNICAL DATA: Mamiya RZ 67, 50mm wide angle, 1/30, f/4.5, Fujichrome Velvia, tripod.

When the sun is close enough to the horizon that your shadow falls on your subject, you need to find a creative solution to this problem. You may also need to settle for a shot that is effective but different from your original vision.

I had to shoot from an angle off to one side from the direction of the light when I photographed this young girl wearing a wine festival costume in Eger, Hungary. This meant that I was off center from direct front lighting and that the shadow on the side of her face would now be included in the shot. If my model turned toward the lens axis, her nose would have cast an unattractive shadow across her cheek. My compromise was to ask her to face the sun while I photographed her from the side. This isn't terrible, but it's not what I originally wanted.

TECHNICAL DATA: Mamiya RZ 67, 250mm telephoto, 1/125, f/5.6, Fujichrome Velvia, tripod.

Midday

The low-angled light early and late in the day is considered more beautiful than the harsh, overhead light of midday, the period from approximately 11:30 A.M. to 3:30 P.M. in the temperate zones. (These times are only to give you an idea of what I mean by the term "midday"; the actual times will vary as you move toward the poles or the equator and as the seasons change.) While it is true that midday light is far from ideal, you shouldn't put away your camera either. It is tougher to find great pictures at this time of day, but you can do it. In fact, you often stumble on fantastic photo opportunities at a time when the light isn't good. When a bull elephant in the Kenyan Maasai Mara charged right at my vehicle, I couldn't pass up that shot—even though the tropical sun was shining brightly overhead. (See page 39.)

You'll see only two pictures of people and only two scenics in this chapter. Neither of these subjects, with very few exceptions, can be effectively photographed in the middle of the day. Overhead lighting causes unsightly glare on people's foreheads and noses, while the brow, which protrudes half an inch over the face, casts dark shadows on the eyes. (If you carry a reflector in your camera bag, you can manipulate the light to make it more flattering, a must if you're shooting people at this time of day.) Landscapes at midday tend to look flat, with little texture and no dimensionality or warmth. The harsh contrast between highlights and shadows tends to bathe the land in garish colors.

Having said this, there are interesting exceptions. When the sun is overhead, an opaque object can become a silhouette, or a transparent one become translucent. If you stand beneath a tree, looking up at the sky, the leaves will be silhouetted against the sun. A strong graphic design in the branches and leaf patterns will make this a dynamic image. If you shoot a close-up of a palm frond under similar circumstances, the sun will highlight the structure within the palm, and it will glow with an intense green color.

Canyon walls and architectural facades can also be photographed successfully at midday. When the overhead sun illuminates a cliff face from above, the texture of the rock is enhanced by the contrasty sidelighting. The illumination is skimming the surface, and this extreme angle of light creates the highlights and shadows that comprise texture.

Don't hesitate to include the sun in your composition. You won't harm the lens or the shutter, or burn a hole in the film. When properly exposed, the sun adds a dramatic element to a picture. When a wide angle lens is used with a small lens aperture—in the f/11 to f/22 range—the sun appears to look like a star. No filter is required to achieve this effect. The "sun star," when artistically included in the frame, transforms an ordinary picture into an exciting one.

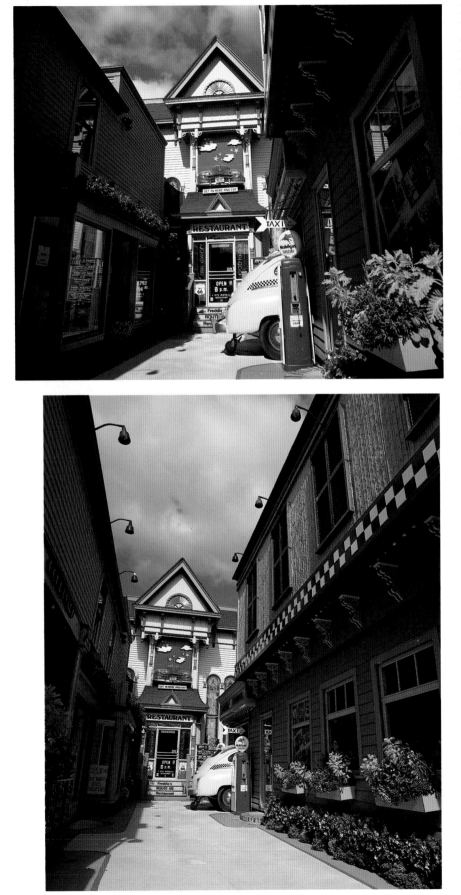

Midday, overhead sunlight creates an extreme contrast between the values of the dark and the light areas. Under that type of light, exposing correctly for the highlights causes the shadows to be two to three f/stops underexposed. But this shot illustrates a situation where that extreme contrast between light and dark is an opportunity rather than a problem.

I photographed this slice of Americana in downtown Bar Harbor, Maine. Here, the dark storefronts frame the out-of-place car and gasoline pump. I thought the contrasty lighting would be quite effective for this rather bizarre scene because it would emphasize the car's position.

I used both a wide angle and a normal lens to capture the scene. After comparing the two shots, I decided I preferred the shot with the normal lens. The wide angle lens seemed to push the car and pump too far away, making them look insignificant.

TECHNICAL DATA: Normal Lens Shot—Mamiya RZ 67, 110mm lens, 1/15, f/22-f/32, Fujichrome Velvia, tripod. Wide Angle Lens Shot—Mamiya RZ 67, 50mm wide angle lens, 1/15, f/22-f/32, Fujichrome Velvia, tripod.

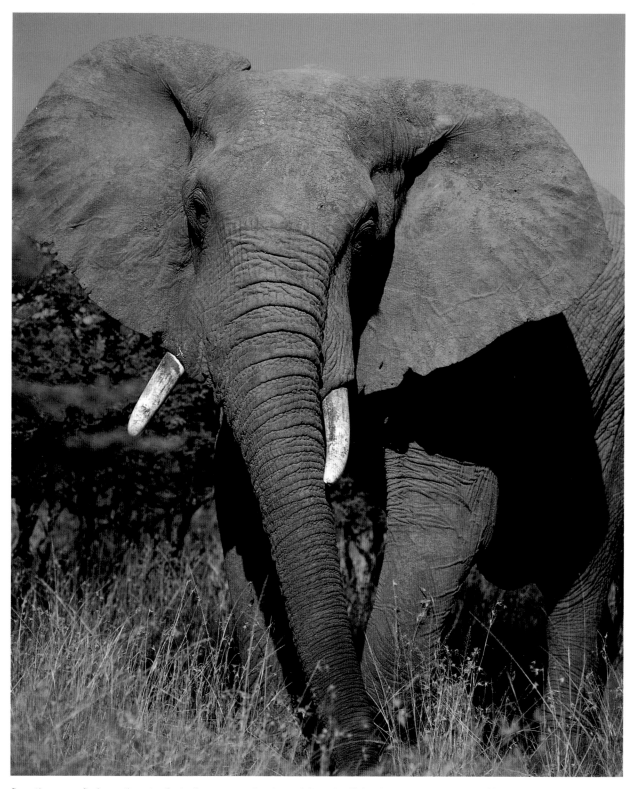

Sometimes you find an otherwise fantastic shot when the lighting is far less than ideal, and you take it anyway. I was in the Maasai Mara in Kenya when this African elephant charged toward my vehicle at about 2:00 P.M. The sun was directly overhead, but I couldn't pass up the chance to get this dramatic shot of a bull elephant so close to my camera. Although the shot would have been better in the low-angled light of late after-noon, the slope of the animal's head meant that harsh shadows wouldn't show on the face. If elephants had a protruding brow similar to the human brow, the overhead light would have cast black shadows on the eyes, and I wouldn't have been able to get a usable photo.

Most photos of animals taken in the wild are shot with a telephoto lens because you can't get close to them. In this case, I could use a normal lens by waiting until the elephant came close to the vehicle. When he filled the frame, I tripped the shutter, the driver gunned the engine, and we took off as soon as I got the shot.

TECHNICAL DATA: Mamiya RZ 67, 110mm normal lens (comparable to a 50mm lens in 35mm photography), 1/250, f/11-f/16, Fujichrome Provia, hand-held.

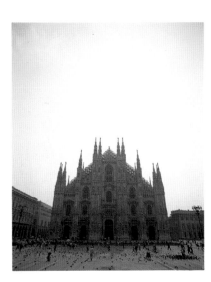

When you do shoot during the middle of the day, take the time and the position of the sun into consideration. These two photos of the Duomo in Milan, Italy, taken two hours apart, show a remarkable difference in color, contrast and impact. With the sun positioned behind the cathedral but still providing overhead lighting, the contrast is extreme. The color of the stonework is dull; it even looks grimy. Although this image may appear somewhat underexposed, it isn't. If it had received more light, the concrete on the ground would be overexposed.

Two hours later, the sun was still overhead but had moved toward the west. The low clouds had burned off by the time this shot was taken, so I had a more attractive sky than before. The change in sky alone, however, did not make the second shot better. Now, the front lighting on the Duomo makes a world of difference. The warm tone on the facade is much more attractive and inviting than the colors in the earlier picture.

You cannot photograph opaque objects, such as buildings, with back lighting unless your objective is a silhouette. If you want to show detail in the subject or to show both highlights and shadows in the subject and the surrounding area, wait until the sun moves in front of the structure before shooting.

TECHNICAL DATA: Back lit image—Mamiya RZ 67, 50mm wide angle lens, 1/125, f/5.6, Fujichrome Velvia, tripod. Front lit image—Mamiya RZ 67, 50mm wide angle lens, 1/125, f/8-f/11, Fujichrome Velvia, tripod.

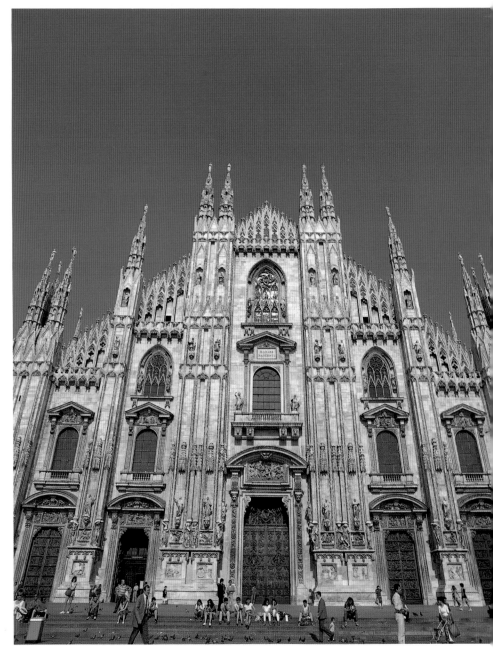

In many parts of the world, the sun is never directly overhead—even at high noon. For example, in North America the sun is south of its zenith at midday in the autumn, winter and spring. In the summer, the sun does move closer to a point ninety degrees above you in the sky, but it never quite gets there. (Only at or near the equator, the area bounded by the tropic of Cancer at the north and the tropic of Capricorn at the south, will the sun be directly overhead at least one day of the year.) Since the sun is off the zenith even at noon, it is at a slight angle to the subjects we photograph, partially offsetting the effects of shooting when the sun is high in the sky.

While traveling near Woodstock, Vermont, I discovered this unusual herd of cows. These large, stuffed toys mounted for display on stakes in a front yard attracted a lot of attention—and business—for their creator. I took the shot at midday but, because it was October, the sun was low enough in the sky to light the scene from the front rather than the top. Late afternoon light would have lit the scene at a better angle and given it a more attractive, warm color, but I didn't have the time that day to wait for the light to change.

When shooting scenics, I frequently use a classic landscape photography formula that I applied to this image as well. The technique involves exaggerating the foreground by making it seem larger than it did in reality, including an interesting background, and extending the depth of field from front to back. You accomplish this by using a wide angle lens (in the 35mm format, you should use an 18mm, 20mm, or 24mm lens) placed very close to the foreground and a small lens aperture (f/16 to f/32). In this shot, the camera was four feet from the nearest cow. You can use this formula for landscape photography with any natural element of interest, such as a clump of wildflowers, a gnarled tree, or textured or weathered rock.

TECHNICAL DATA: Mamiya RZ 67, 50mm wide angle lens, 1/30, f/16-f/22, Fujichrome Velvia, tripod.

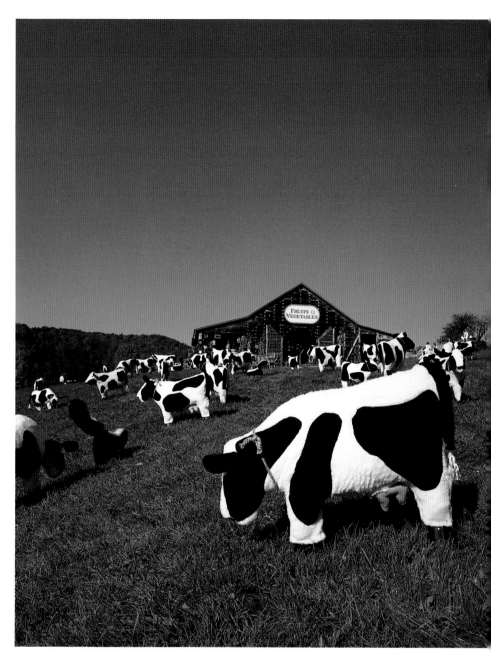

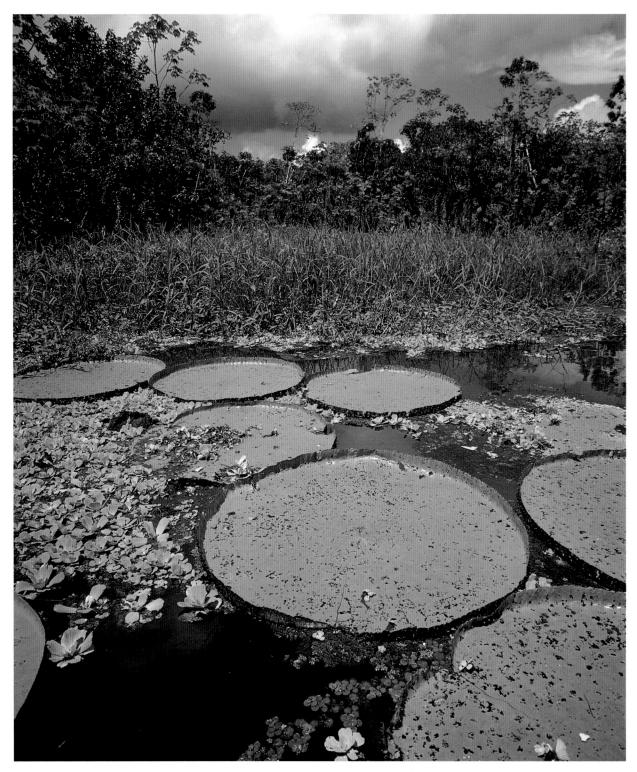

The midday sunlight is directly above you when you are at or near the equator. That means subjects lying on a flat surface, such as the ground or a body of water, are front lit by beautiful light similar to that falling on a vertical surface facing a late afternoon sun. Only the warm coloration of the late afternoon light is missing.

This shot of giant lily pads floating on a tributary of the Amazon River in Peru gains impact from the contrast between the sunlit pads and the threatening clouds in the distance. We don't usually think of midday light as being dramatic, but angry storm clouds can transform any scene into a powerful statement. Had the sky simply been blue, the photo would be less dramatic.

In the tropics, the contrast between light and shadow is extreme, so I used Fujichrome 50D film, which is less contrasty than Velvia. I hoped this would prevent the shadows in my photographs from going black.

TECHNICAL DATA: Mamiya RZ 67, 50mm wide angle lens, 1/60, f/11-f/16, Fujichrome 50D, hand-held.

Choose your subject and its background even more carefully than usual when shooting under bright, overhead sunlight at noon. The subject should usually be somewhat brighter than the background, because the eye always goes to the brightest portion of a photograph first.

Reptiles often seek the bright sunlight in the morning to warm their muscles. I photographed this Parson's chameleon warming himself in the sun about 11:00 A.M., just before the sun reached the top of its arch. I positioned the camera so the dark leaves behind the chameleon would provide some contrast against the bright green reptile. If the leaves had been similar in tonality, the background would have taken attention away from my subject.

TECHNICAL DATA: Mamiya RZ 67, 350mm APO telephoto, 1/400, f/5.6-f/8, Fujichrome Provia 100, tripod.

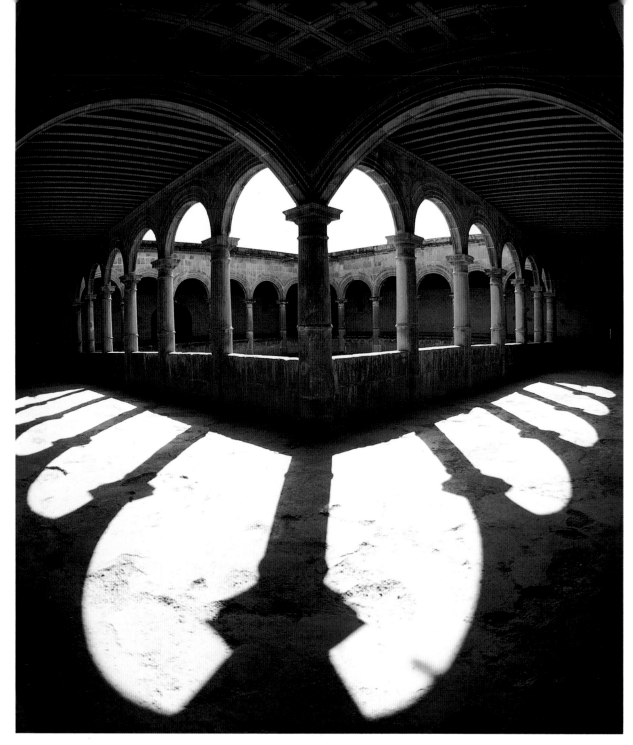

Direct overhead sunlight is harsh and unflattering for most subjects. If you're carefully studying a scene, however, you can sometimes spot compositions that take advantage of the play of light and dark that produces interesting patterns.

I took this shot in the inner courtyard of a seventeenth-century convent in Actopan, Mexico. The light on the exterior of the building was unattractive, with the roof well-lit by the midday sun overhead, while the brick walls lay in shadow. Even in the courtyard, there was extreme contrast—

three-and-one-half f/stops between the sunlit areas and the much darker, shadowed corridors. This would usually be an undesirable situation, but here the areas of shadow and light on the floor of the courtyard create an interesting pattern echoing the line of arches behind it and the vaulted ceiling above it.

I chose a Mamiya RZ 50mm wide angle lens (comparable to a 24mm wide angle lens in 35mm format) to capture the scene because it would frame a broad area to best capture the graphic shapes of the shadows.

Wide angle lenses also exaggerate distance, so the corridor appears longer in the photograph than it does to the eye.

I determined the exposure by taking a daylight reading on a medium gray subject. Since there were no suitable areas in the scene itself, I placed my gray Lowepro camera bag in the light and took a reading from it with a spot meter.

TECHNICAL DATA: Mamiya RZ 67, 50mm wide angle lens, 1/60, f/8, Minolta Spot Meter F, Ektachrome 64, tripod.

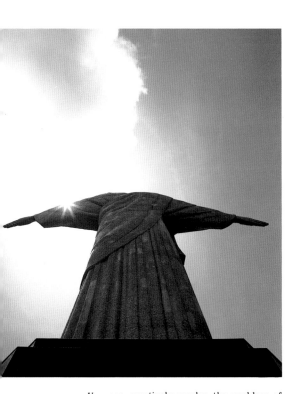

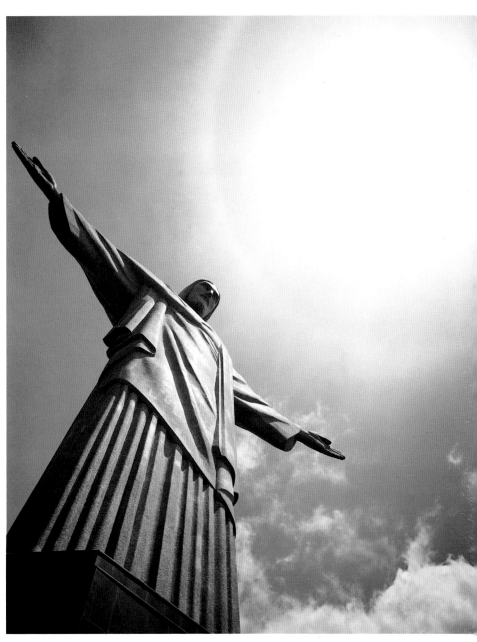

You can creatively resolve the problem of shooting under an overhead sun by using it in your composition. If you can shoot straight up, translucent objects will be backlit, and opaque subjects will be partial or complete silhouettes, depending on your exposure.

The huge statue of Christ in Rio de Janeiro (each hand weighs nine tons) is usually photographed when the sun is low in the sky. I first visited it at midday to find a new interpretation of a monument that's already been photographed many times. Looking up, I saw that the dense humidity had caused a ring to appear around the sun and decided to use that in the composition. I composed the picture from a low perspective with a wide angle lens, which let me include the ring around the sun as well as the entire statue.

I then walked around the base of the monument, looking for another interesting shot. Seen from the back, the statue of the Christ had a dramatic shape and looked quite different from the typical frontal view. I moved the camera position until the sun just peeked around the edge of the arm.

Both exposures were based on meter readings taken from the dark blue portion of the sky, which I used as a medium gray reference (a middle-toned area). As a general rule, if you get the correct exposure for the sky, the rest of the exposure values will fall into place. This occurs because the middle-toned blue sky is reproduced on film exactly as you saw it when you took the shot—in the middle of the exposure spectrum. When middle-toned subjects turn out to be middle-toned on the slide, then the highlights remain bright, as they should be, and the darker portions of the image remain darker than medium gray, as they should.

TECHNICAL DATA: Both shots—Mamiya RZ 67, 50mm wide angle lens, 1/60, f/11, Minolta Spot Meter F, Fujichrome Velvia, tripod.

The stone steps in the ancient theater of Epidaurus in Greece provided me with an opportunity to create an exciting shot under the direct light of the midday sun. The top of each step was highlighted while the vertical face remained in shadow. The contrast between the light and dark areas of the steps defined a striking shot. In fact, this shot could only have been made under the bright, midday sun. If I had taken the shot in the late afternoon when the angle of light was low, the hills surrounding the theater would have blocked the light from hitting the steep steps.

I used a telephoto lens to crop tightly on the graphic design, eliminating the rest of the theater and the trees behind it. This type of close-up treatment transforms the photo from a straight, documentary shot into an intriguing, more abstract image.

TECHNICAL DATA: Mamiya RZ 67, 350mm APO lens, 1/30, f/8, Fujichrome Velvia, tripod.

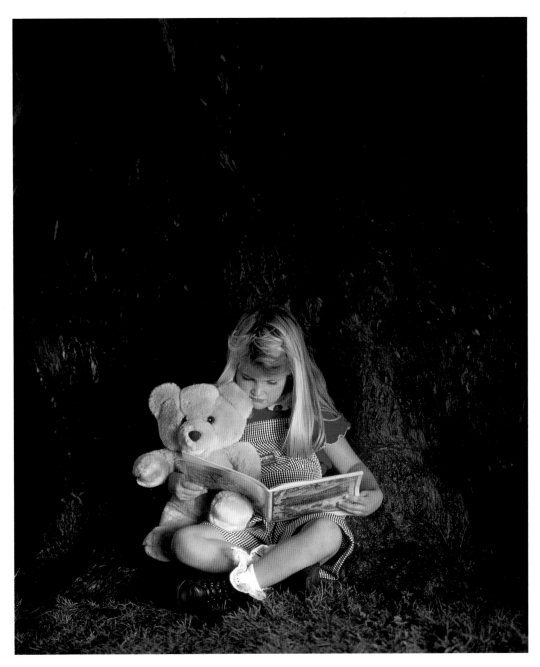

Shooting under midday light can be tough, especially when you see only unattractive, harsh, flat light around you. Instead of putting your camera away, try a little creativity. I wanted to get a charming shot in the park of a little girl reading a book to her teddy bear. Since this would be a scheduled shot based on the model's availability, I could plan to bring an assistant and some extra equipment if I needed it.

I ended up having to take this photo in the early afternoon. If I posed the child in the direct sunlight, her pale complexion would reflect the bright light and some of the texture of the skin wouldn't show up. In addition, dark shadows caused by the high angle of the sun would have hidden her eyes. So, I placed my young subject in the shadow of a large tree.

I asked my assistant to stand in the sunlight off to the side of our subject and to hold a Photoflex gold reflector that would bounce a warm glow back onto the child. The assistant could control the concentra-tion of the light by flexing the round reflector, keeping the tree bark relatively dark compared to the child. I determined my exposure by holding a Minolta Flash Meter IV that can read either ambient or flash illumination in front of the subject with the white hemisphere on the meter's face pointing toward the camera.

TECHNICAL DATA: Mamiya RZ 67, 180mm lens, Photoflex gold reflector, 1/30, f/4.5, Minolta Flash Meter IV, Fujichrome Velvia, tripod.

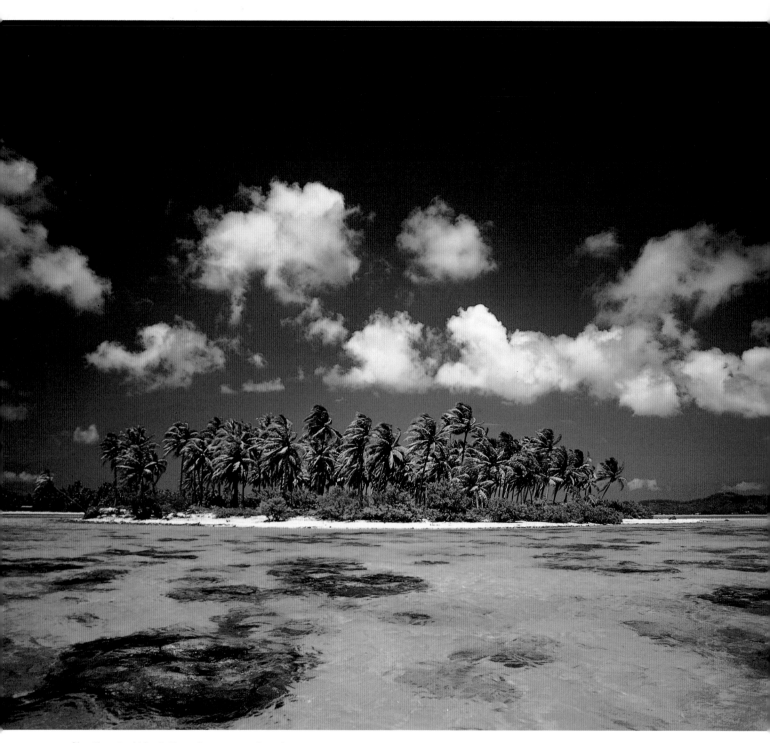

Shooting at midday is the only way to catch the essence of some places. I first noticed this phenomenon in Tahiti. The intensity of the aquamarine and turquoise colors of the water is noticeable only when the direct rays of the sunlight penetrate the water. I could take beautiful shots of the sky at sunset and sunrise, but the color of the lagoon became an unimpressive dark blue.

I took this shot of a *motu* (a small coral island covered with palm trees) from a boat in the lagoon surrounding Bora Bora, Tahiti's most famous and beautiful island. I didn't have to use a polarizing filter to intensify the color. I simply took the shot in the middle of the day with Fujichrome Velvia film. The gentle rocking motion of the boat made it impossible to use a tripod and challenging to level the horizon line with the camera's viewfinder. I shot lots of film for insurance.

TECHNICAL DATA: Mamiya RZ 67, 50mm wide angle lens, 1/125, f/8-f/11, Fujichrome Velvia, hand-held.

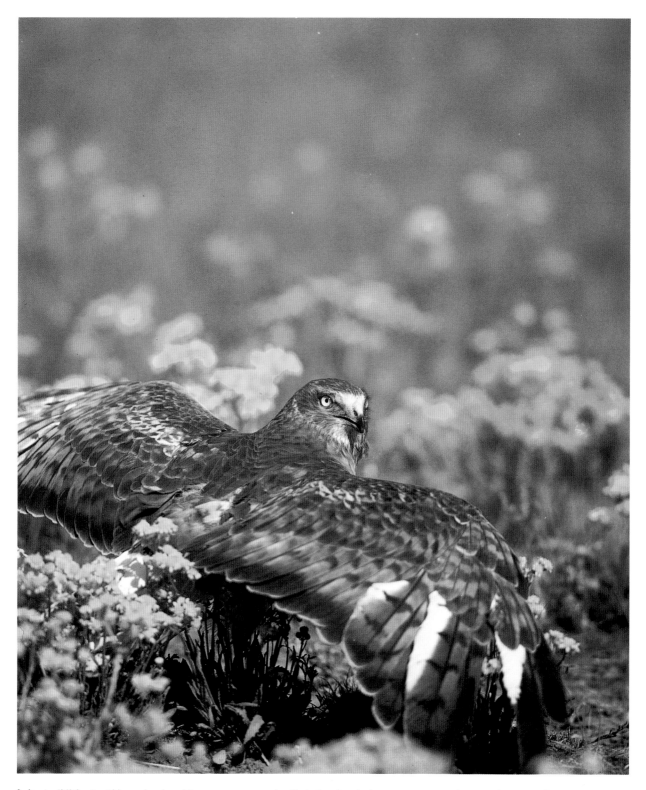

I shoot wildlife at midday only when I have no choice. Midday photos like this shot of a Swainson's hawk work only because the subject itself is very arresting. The outstretched wings of the raptor, the flowers and the low perspective all add drama to the image. The angle of the wings and head were such that harsh shadows were avoided, but the lighting was flat with no texture or warmth. I would have preferred, of course, to find this shot with low-angled sunlight either front or back lighting the bird, but you can't always find those situations. When you stumble on one, you appreciate your luck and, the rest of the time, work hard to get a good shot with the lighting you do have.

TECHNICAL DATA: Mamiya RZ 67, 500mm APO telephoto, 1/250, f/6.7, Fujichrome 50D, tripod.

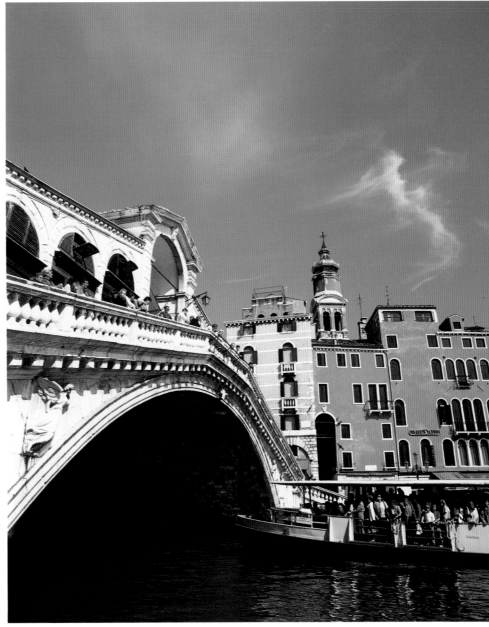

The narrow canals in Venice, Italy, are surrounded by multi-storied medieval buildings that shroud the dark water in deep shadow. Sunlight penetrates down to the level of the waterways only during the middle of the day. When I set up this midday shot of a carnival participant in a gondola (above), I was hoping for the soft, muted light of an overcast sky rather than the harsh light of a clear day. However, when the sun broke through the clouds and struck the satin costume of my model, the color was so stunning that I excitedly shot several rolls of film.

The juxtaposition of the bright, shiny fabric of the model's costume and the black shadows of the canal make this shot work so well. Because I chose to expose for the sunlight, the shadows, about four f/stops darker, lost all detail. The sunlit walls behind the model provided a sense of place, but the darkness on either side of her dramatically framed my subject. Note that the model's face is angled slightly upward. This helped eliminate the harsh shadows on the face that normally plague photographers when they shoot portraits at midday.

The midday sun was more of a handicap

in the photo above. The Grand Canal is the widest one in Venice, and its width lets the sun illuminate the buildings along its bank for much of the day. Unlike many other areas of the city, you can take photos at the level of the waterway most of the day. I photographed the Rialto Bridge, a famous historical landmark, just after midday, however. The light was harsh, creating black shadows everywhere, but I was able to use the intensity of the light to dramatize the colorful scene. The contrasty lighting creates an exciting juxtaposition of the

black shapes created by doors and windows and the colorful buildings. The bridge is shot from a low perspective, with the graphic effect enhanced by my use of a wide angle lens.

TECHNICAL DATA: Carnival costume—Mamiya RZ 67, 50mm wide angle lens, 1/60, f/11, Fujichrome Velvia, hand-held. Rialto Bridge—Mamiya RZ 67, 50mm wide angle lens, 1/125, f/8-f/11, Fujichrome Velvia, tripod.

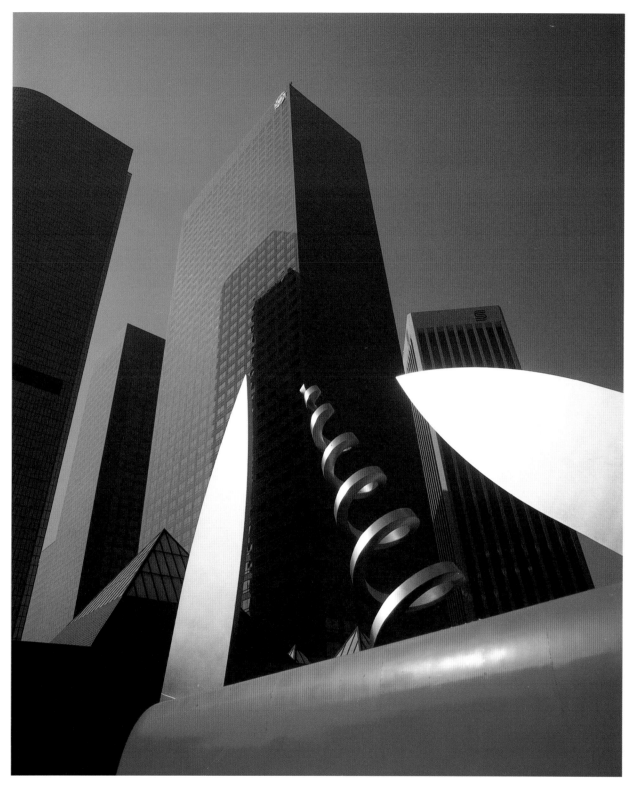

Even undesirable lighting is sometimes not a problem when you shoot pictures composed of strong shadows; bold, graphic lines; and interesting subjects. This juxtaposition of an unusual artwork—a giant jackknife—and downtown Los Angeles was photographed during the middle of the day. (I caused the jackknife to appear disproportionately large by using a wide angle lens.) The image works despite the lack of beautiful, natural light because the entire composition is a contrast of interesting light and dark shapes. Behind the brilliant knife blades angled to catch the sun's light are shadows on the skyscrapers. Beyond the shadows are buildings directly illuminated by the sun. There is also a strong contrast between the hot, red color of the knife and the cool, darker blue of the sky.

The striking angles between graphic el-ements in the composition add an artistic tension to the image. The large blade and corkscrew create graphic "lines" running toward the buildings while the "line" of the small blade runs parallel to the buildings and crosses the "line" extending from the large blade.

TECHNICAL DATA: Mamiya RZ 67, 50mm wide angle lens, 1/60, f/11, Ekta-chrome 64, tripod.

Sunset

Many of my favorite images have been taken at sunset. No other time of day offers such wonderful opportunities to watch the changing light and to position yourself for the best composition. The brilliant color in the sky, the long shadows, pronounced textures, soft contrasts and golden hues make classic shots easy to find at sunset. Sunsets are loved, of course, for those intense colors they produce. But, sometimes, we're disappointed when we get our film developed. The colors we saw aren't the ones reproduced on our film. Because photographic film is manufactured to produce correct colors at specific color temperatures on the Kelvin scale, it reacts to colors somewhat differently than our brains do.

Kelvin is a temperature scale like Fahrenheit and Celsius. The association of color with temperature comes from heating a special piece of metal. When the heated metal glows a bright red color, the temperature is about 2000 degrees Kelvin. A yellowish light corresponds to 3200 degrees Kelvin. White light that approximates daylight is produced at 5500 degrees. When the temperature rises above 6000 degrees, a bluish color is seen.

Daylight film, such as Fujichrome Velvia or Kodak Lumiere, is manufactured to produce correct colors for white light at 5500 degrees Kelvin. Film made for shooting under tungsten illumination indoors, such as Fujichrome 64T, is manufactured to produce correct colors when the light is at 3200 degrees Kelvin.

When you shoot a sunset with daylight-balanced films, the results are often more yellow than what you actually saw. This occurs because the Kelvin temperature of a sunset is similar to that of a tungsten lamp, around 3000 degrees. Similarly, shots taken at twilight or dawn with a daylight balanced film will be more blue than what you saw because the Kelvin temperature of sky close to dark is high, perhaps 12,000 degrees. This doesn't mean you shouldn't use daylight film to shoot at these times. As you'll see in this chapter, I shoot daylight-balanced film at sunset with good results.

Another problem that can affect color is incorrect exposure. Many times our meters let us down, especially in situations of extreme contrast or unusual lighting. To keep this from happening to me, I taught myself how to read daylight without a meter. In one week, I trained my eyes to interpret light with respect to shutter speeds and f/stops. To do this, I simplified the "Sunny f/16 Rule" to make it work for me.

The formula for correct exposure when shooting daylight film in bright sunlight is $1/\text{iso}$ at f/16. This means the shutter speed is the reciprocal of the ISO at f/16. For example, if you are shooting Ektachrome 64, the correct shutter speed-f/stop combination to produce a proper exposure is 1/60th of a second at f/16. There isn't 1/64th on the shutter speed dial, so the closest speed is used. Since the faster shutter speed of 1/125 is more conducive to hand-holding a camera, I use a combination of 1/125-f/11 for the correct exposure for a bright sunny day from mid-morning to late afternoon.

The key to extrapolating the Sunny f/16 Rule for other light conditions is to have only one variable. If the shutter speed and film ISO remain the same, then the only variable is the lens aperture. If we use ISO 64 and a shutter speed of 1/125, then a cloudy but bright day (faint shadows) is f/8, open shade is f/5.6, and a thick overcast is f/4. If you take pictures on bright sand or snow with direct sun illuminating the scene, f/16 is correct. (Sand or snow under cloudy conditions requires a different exposure that will depend on the density of the cloud cover.) In the American Southwest, f/5.6 gives you a correct reading when the sun is ten minutes away from the horizon. When the ball of the sun sits on the horizon, f/4 works well.

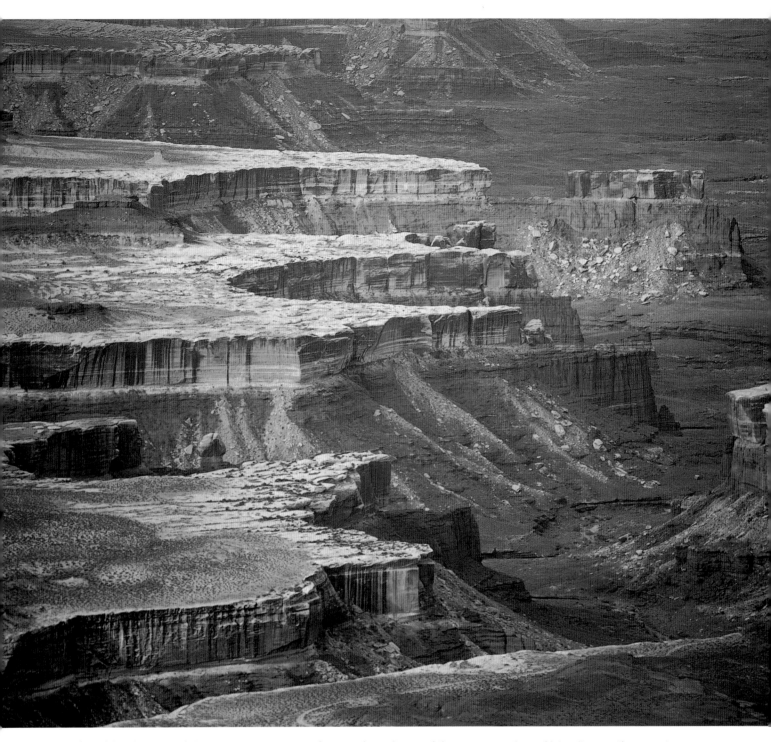

One of the advantages of shooting at sunset rather than sunrise is the amount of time you have to watch the light change and to prepare yourself for the shot. There is much more time to choose the camera position, compose the picture and pick the right moment to trip the shutter than there is at sunrise.

I took the photo above of Canyonlands National Park on an overcast day when the light was muted. It is a beautiful sunrise shot that was taken as I waited for a window to open in the dense cloud cover. It never came. Compare the cool tones of the overcast sunrise to the exquisite sunset lighting of the image on page 55. It has a completely different mood. The magical golden light transforms the canyon below into a fairytale landscape. I watched the light change from the rim of the Green River Overlook for an hour before taking this picture just a few minutes before sunset. As the sun sank lower toward the horizon, the low angle of the light grazed the land and gently highlighted the western facing cliffs.

The qualities of the light—its color, direction and intensity—are the same at sunrise and sunset. Both times of day offer the same beautiful light; only the direction changes. However, when overcast conditions prevent the sun's light from reaching the landscape, the result is a dull, bluish photograph as seen above.

TECHNICAL DATA: Muted shot—Mamiya RZ 67, 350mm APO telephoto lens, 1/30, f/5.6, Fujichrome Velvia, tripod. Sunset shot—Mamiya RZ 67, 350mm APO telephoto lens, 1/60, f/5.6-f/8, Fujichrome Velvia, tripod.

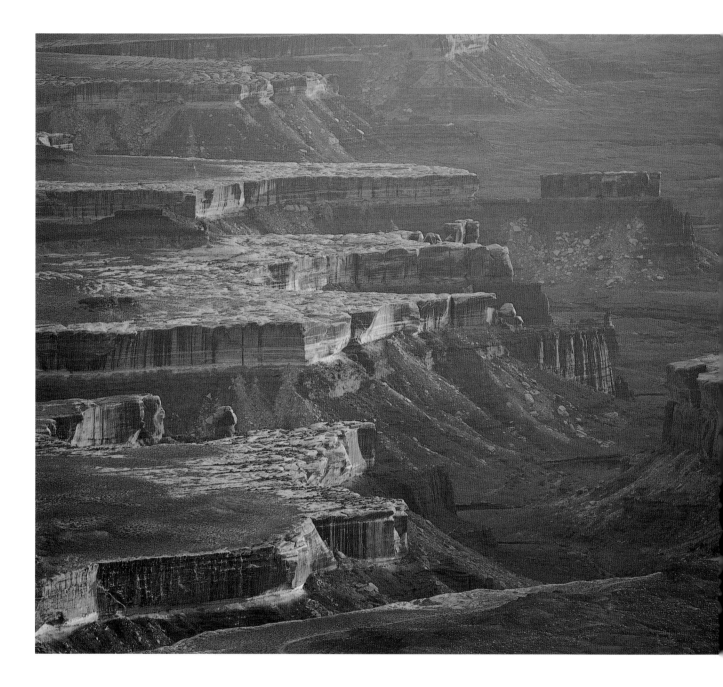

I took the midday photograph above when I first started shooting. Then I was very pleased with it, but I've since discovered how much more beautiful a shot at sunset can be. The interesting division of the frame into strongly contrasting areas of light and dark, the moody colors, and the emphasis placed on the butte by the light make the sunset exposure at right more compelling.

Don't take a few great frames and then pack up your gear when shooting a beautiful location such as Monument Valley at sunset. There may be more—and even better—shots to come. Even after sunset, it can take about twenty minutes for the sky to begin its show. Not every night, but often, intense pink-orange hues dominate the heavens for a few short minutes. You won't want to miss the show even if it takes many tries to catch it.

TECHNICAL DATA: Midday—Mamiya RZ 67, 50mm wide angle lens, 1/60, f/11-f/16, Fujichrome Velvia, tripod; Sunset—Mamiya RZ 67, 50mm wide angle lens, 1/8, f/16, Fujichrome Velvia, tripod.

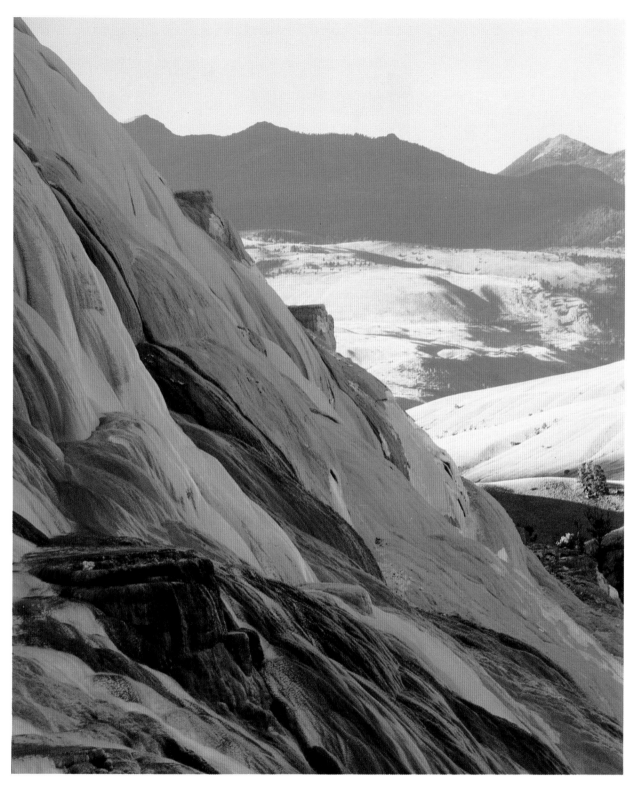

While the contrast between light and dark is diminished when the sun is low to the horizon (unless you're shooting into the sun), the color contrast increases. So, when I'm shooting at sunset, I often look for compositions where I can include sunlit areas as well as portions of a landscape protected from the soft, yellow light. I compose a shot so the blues of the shaded areas are juxtaposed with the golden hues of the setting sun, because the pleasing mixture of color adds a unique dimension to the image.

The mineral floes of Mammoth Terraces in Yellowstone National Park, a unique geothermal region, offer a myriad of subtle colors to photograph. At sunset, the play of light between the minerals and the surrounding landscape makes the scene even more intriguing to shoot. Here, I used the weak sunlight washing over the distant hills as a backdrop to the diagonal mineral formation. Note the effective contrast between the cool tones of the minerals and the golden hills in the midground.

The reduced contrast at sunset (and in the early morning) expands the latitude of film and reduces the possibility of poor exposure. Even with a contrasty film like Velvia, you can include both shaded and sunlit areas with no loss of detail.

TECHNICAL DATA: Mamiya RZ 67, 50mm wide angle lens, 1/15, f/16-f/22, Fujichrome Velvia, tripod.

These four shots of model Rondi Ballard illustrate how the color of light at sunset changes in a short time. All the photos were taken within an hour of sunset, yet the color of Rondi's skin changed from soft, warm flesh tones to an intense orange hue as the sun sank lower in the sky. Note how much change occurs between the last two photos, which were taken only fifteen minutes apart.

The variations in the shadows and textures were achieved by simply having Rondi stand at different angles to the sun and by moving the camera position to achieve a desired effect. In the first shot, above, she stood toward the sun. Having her head turned a bit to one side created dramatic side lighting that strongly highlighted one side of her face while leaving the other in deep shadow. In the second frame, above right, her entire body was side lit, as was her face. Fifteen minutes before sunset, opposite, left, her skin tone was now more yellow-orange. The shot was again side lit, but this time she faced the sun, and I moved the camera position to her side. The final shot, opposite, right, was front lit with the intense orange color of the lowest-angled light possible in nature.

TECHNICAL DATA: All four photos were taken with a Mamiya RZ 67, a 350mm APO telephoto lens, and Fujichrome Provia 100 film and a tripod. The first shot, above left, was taken at 1/250, f/5.6-f/8; shots two and three, above, and opposite, left, at 1/250 and f/5.6; and the last shot, opposite, left, at 1/125 and f/5.6. Provia—available as 100, 400 and 1600 ISO—has very saturated color that is similar to, but a bit less intense than, Velvia. Provia is also slightly more grainy than Velvia, but similar in grain structure to Fujichrome 50D and Kodak's Lumiere.

Low light photography is ideal for wildlife. The lower contrast, which brings out the rich textures of hair and fur, and the presence of a catchlight in the eyes enhances animal portraits. In addition, the weak sun doesn't make animal subjects squint from the glare.

I followed these two black-tailed fawns on Vancouver Island in British Columbia for two hours, but I took the best shot about fifteen minutes before I lost the sunset lighting. Due to the low light level, I was shooting with the telephoto at its maximum aperture, which meant that my depth of field was extremely shallow. In order to get both fawns in focus, I could only shoot when they were equidistant to my lens. This is the price I pay for shooting with slow, fine-grained film. If I had been shooting a faster film in the diminished light, I could have closed the lens aperture down for more depth. I prefer the fine-grained film because it provides better color saturation, more fine detail, and a sharper photograph.

Both animals looked at the camera only once—and at that moment, they happened to be in the right position in relation to my lens. As the low-angled light caught their eyes, I made the exposure.

TECHNICAL DATA: Mamiya RZ 67, 360mm telephoto lens, 1/125, f/6, Fujichrome 50D, tripod.

Sunset lighting is beautiful not only for shooting nature but also for photographing virtually everything else. The intensity of this 1931 Packard's colors are dramatized by taking advantage of the golden sunlight. It was parked at an angle to be directly front lit. Side lighting might have picked up dust or some minor imperfections in the paint, and backlighting doesn't work unless the subject is translucent or has a dynamic shape that works well in silhouette.

A TTL meter could have read this shot accurately, but I used instead my Minolta Flash Meter IV (which is also an incident meter) because I've learned to trust it in so many circumstances. I pointed the white hemisphere on the meter toward the camera so the angle of the light striking the automobile was the same as it was in striking the meter. If the incident meter is turned at any other angle, the reading may be wrong.

TECHNICAL DATA: Mamiya RZ 67, 50mm wide angle lens, 1/125, f/5.6, Ektachrome 64, Minolta Flash Meter IV, tripod.

Understanding the qualities of light will help you transform photographic ideas roaming around in your brain into exciting photos. I know that low-angled light produced by the sun being close to the horizon brings out the rich texture of sand, rocks and short vegetation. I also know that sunset brings out the texture of a vertical wall, if the wall runs east to west.

With that in mind, I envisioned a shot where the saturated colors of this Indian blanket would be juxtaposed with the rough, textured look of a neutral-toned adobe wall. I drove around Santa Fe, New Mexico, until I found the perfect wall. The late afternoon sunlight grazed the adobe wall, creating an artistic backdrop for the blanket. I arranged the colorful material in a pleasing design and waited to shoot until about twenty minutes before the sun set.

Note the large shadow cast by the blanket. If I had composed the shot with the shadow in the center of the frame, a reading with the typical, center-weighted TTL meter would result in an overexposure. The meter is programmed to give the most weight (or consideration) to the amount of light or dark at the center of the composition; the presence of the shadow would indicate that the whole picture was too dark.

Since the shadow is off center, it has less effect on the meter reading. To be absolutely sure that the center-weighted system isn't thrown off, I pointed the camera's meter at the sunlit portion of the adobe wall and used that reading for this shot.

TECHNICAL DATA: Mamiya RZ 67, 110mm normal lens, 1/60, f/11, Fujichrome Velvia, tripod.

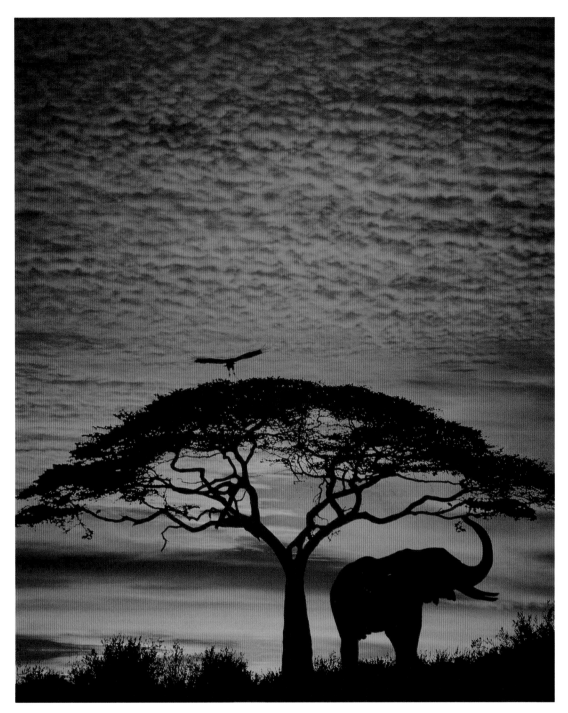

The most important factor in making silhouettes successful is graphic design. Beautiful lines and interesting shapes characterize all exceptional silhouettes. In nature, it is a continuing challenge for photographers to find striking shapes in trees, animals, mountain ridges and other natural subjects.

Once you find a dynamic design, the next factor to consider is the background. It will, by definition, be lighter than the subject. The most exciting background is one with strong color and an interesting pattern to complement the stark graphic silhouette. The sunset sky in this shot taken in Kenya is about as dramatic as they come. It makes the shot. The elephant and the vulture certainly are crucial elements in making this a remarkable image, but it would have had less impact without the electrifying sky. If the sky were overcast, this would look like a black-and-white picture, even though it was photographed on color slide film.

The exposure was taken from the sky. There was really nothing else from which I could take a light reading. Any TTL meter would have read this situation correctly, but I prefer to use my Minolta Spot Meter F. I selected a middle-toned segment of the clouds to get the exposure information.

TECHNICAL DATA: Mamiya RZ 67, 250mm telephoto lens, 1/125, f/4.5, Fujichrome Provia 100. I made the shot with the camera and telephoto lens resting on a beanbag on top of my safari vehicle.

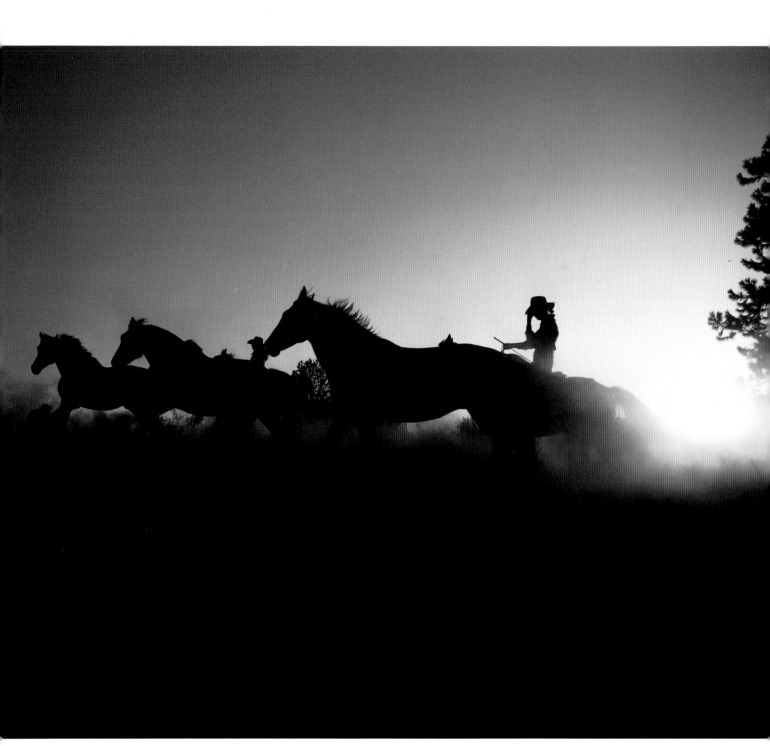

It can be challenging to shoot action at sunset. You must decide whether to use a film that's fast enough to freeze the action but will probably be more grainy than a slower film. You must also decide whether to sacrifice depth of field for the additional light-gathering ability of the maximum lens aperture. For this shot, the answer to both questions was "yes."

I shot Fujichrome 100D, a medium speed film with a slightly coarser grain than the slower Velvia, to be able to use a shutter speed fast enough to freeze the action. Since I was shooting into the sun for dramatic silhouettes, I knew the medium speed film would still be fast enough for the shot. Even if it was somewhat underexposed, the increased contrast and lack of detail is acceptable when shooting silhouetted forms.

I chose the maximum lens aperture in order to have a shutter speed of 1/250 to freeze the action. I used a wide angle lens to help achieve a high degree of sharpness *and* freeze the movement of the galloping horses. Because wide angles have more depth of field than telephoto lenses, I had considerable depth of field even at the maximum aperture of f/4.5.

TECHNICAL DATA: Mamiya RZ 67, 50mm wide angle lens, 1/250, f/4.5, Fujichrome 100D, tripod.

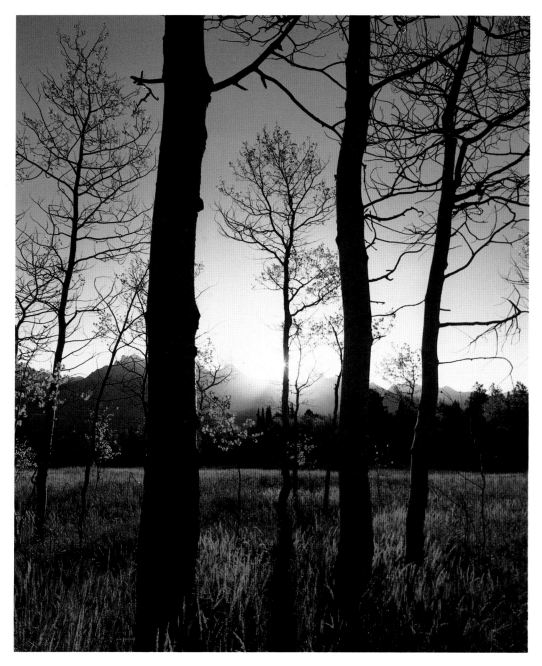

When the sun sets behind opaque objects, such as mountains, tree trunks, rocks and animals, you'll get a silhouette. On the other hand, when translucent subjects, such as leaves and grasses, are backlit by a low sun, they glow from the brilliance of the light passing through them. This translucent glow is one of the most beautiful effects in photography.

Autumn scenes lend themselves to backlighting because the warm tones of the foliage and the golden light complement each other as you can see here. This image was taken near Jackson, Wyoming, looking west toward the Grand Tetons. I waited until the sun was just about to set behind the mountain ridges when I made the exposure. This timing afforded me the lowest possible angle of sunlight, which would produce the longest shadows and the warmest light.

Note how I positioned my camera so a single, slender tree was placed in front of the sun. When the sun is included in the frame, unattractive, hexagonal flare spots frequently occur from reflections within the optics of the lens itself. This often can be avoided by blocking the sun, either partially or fully, with one of the elements in the picture as I have done here with the tree. Although the sun could be only partially blocked so that its brilliant light bled around the tree a bit, there are no flare spots.

TECHNICAL DATA: Mamiya RZ 67, 50mm wide angle lens, 1/8, f/22, Fujichrome Velvia, tripod.

The contrast between strong, directional lighting and dark tonal areas always adds drama to a photograph. I was on Pfeiffer Beach on the Big Sur coastline of northern California when the setting sun and a high tide came together for this image. As the ocean roared through the opening in the rock wall, the golden light of the low sun streamed through the hole. The sunlight cut through the fine mist and created sharply defined shafts of light.

I couldn't read the lighting in this situation with either a reflective or an incident meter. There is virtually no middle toned area to read, and the light falling on the camera position was completely different than the light on the subject. I knew the rock wall, which faced away from the light, would be dark. At the same time, the brilliant sunlit mist would be lighter than middle toned. My only option was to use the Sunny f/16 Rule (correct exposure for midday sunlight equals f/16 with a shutter speed of 1/iso) to determine my exposure. Sunset lighting is usually 1/125 at f/5.6—or very close to it—so that's what I used.

TECHNICAL DATA: Mamiya RZ 67, 180mm telephoto lens, 1/125, f/5.6, Ektachrome 64, tripod.

Translucent subjects backlit by the sun are exciting images to capture on film. Cactus needles, leaves, seed pods, grasses, sheer fabric, wind surfers' sails and many other subjects are dramatized by strong backlighting.

I placed a seed pod I found near Taos, New Mexico, directly in front of the setting sun to partially block the intensity of the light. This decreased the intense contrast between the sun and the shimmering periphery of the pod. The positioning also helped prevent unwanted lens flare.

Macro photography is dramatized by sunset lighting. If you study small objects through a macro lens, extension tubes or bellows, the brilliant rim lighting or transillumination (light coming through a translucent object) can transform an ordinary close-up into a dazzling image. Be careful about your meter readings, however. Don't let the brilliant light coming from behind your subject throw the meter reading off. Make sure that your reflective meter—backlighting can never be read by an incident meter—takes most of its information from the middle-toned portion of the picture. If you specifically want an underexposed, dramatic silhouette, take a TTL meter reading of the sun and your subject. To determine the correct exposure of the seed pod, I took a spot meter reading of the sky about twenty degrees away from the sun, and then underexposed one f/stop to prevent the pod from being overexposed.

TECHNICAL DATA: Mamiya RZ 67, 110mm normal lens, #1 extension tube, 1/60, f/8, Ektachrome 64, tripod.

Learning to recognize unique photographic situations and then to take advantage of them will distinguish your photography from the crowd. When I saw this horseman riding in a dense cloud of dust, I quickly realized that the strong sunset backlight would dramatize the image more than front or side lighting would.

The light coming through the dust cloud was brilliant. If I underexposed the picture, I could turn the cowboy into a true silhouette. On the other hand, if I allowed the bright light to envelop him, the ethereal quality of the light would appear closer to what I saw with my eyes—a ghostly figure coming out of the sunset. Because I felt that the latter would make the better shot, that's what I did. I didn't have time to take a light reading with a meter, so I used my working knowledge of the Sunny f/16 Rule (see page 66 for a discussion of the rule) and judged an exposure of 1/250 at f/8 for ISO 100.

The dust was so thick I could hardly breathe, but my biggest fear was potential damage to my camera. Dust is second only to salt water as a camera killer. I partially covered my Mamiya with my shirt and composed the shot, trying to keep the rider in focus.

TECHNICAL DATA: Mamiya RZ 67, 180mm telephoto lens, 1/250, f/8, Fujichrome 100D, hand-held.

A cloudy sky can often ruin a good sunset by blocking the low-angled light just before the sun sinks below the horizon. On the other hand, clouds can create dramatic shadows as the golden light streams through an opening and hits the landscape like a giant spotlight.

Here, clouds to the west filled Canyon de Chelly in Arizona with deep shadows, but a small window permitted the yellow light to strike the top and middle of Spider Rock. The contrast between the illuminated upper portion of the column against the background of shadows makes the picture work. In addition, the long shadow of the rock cuts across a sunlit portion of the canyon to add further to the juxtaposition of light and dark.

When shooting transparency film, I nearly always expose for the highlights. If the brighter portions of the picture are correct, shadows can go dark, and the eye will accept the loss of detail. However, if the darker portions of the photograph are exposed correctly while the highlights are overexposed, the viewer feels the picture looks "wrong."

TECHNICAL DATA: Mamiya RZ 67, 50mm wide angle lens, 1/125, f/4.5, Fujichrome Velvia, tripod.

You can capture dramatic silhouettes at sunset only if your subject has a strong, graphic shape. Carefully analyze the silhouettes you photograph. Not every dark object against a sunset sky will become a successful image. Only those with beautiful lines and powerful, simple shapes will work.

This turkey vulture had settled down for the night by the time I positioned myself on a slope to put the sun right behind the scavenger. When the vulture turned to the side, defining the beak and the entire head, I knew I would get a good shot. As soon as he looked forward again, the strong graphic shape would be gone.

I took the light reading with a spot me-ter, placing the one-degree sensor on the orange sky about two feet in front of the vulture's beak. I used this area as medium gray because it approximated a gray card in tonality.

TECHNICAL DATA: Mamiya RZ 67, 500mm telephoto lens, 1/125, f/8, Fuji-chrome 100D, tripod.

Sunset lighting differs in various parts of the world. I have discovered that shooting during the summer months in Europe, for example, is quite different from photography in the American Southwest at the same time of year. The clean, dry air of the mountains and deserts in the American West enhances the brilliance of the sun's light. Even when the sun is touching the horizon, distinctive shadows and golden light infuse the landscape with rich texture and saturated colors.

In Europe, however, the air is so full of particles, primarily water vapor and dust, that the late afternoon sunlight is diffused and weakened. I've held up my hand to a red sun that was about twenty degrees above the horizon without seeing any direct sunlight strike my skin. Only diffused, ambient light, devoid of golden tones, illuminated the last hours of the day.

I photographed this beautiful castle in Anif, Austria two-and-one-half hours before sunset, but the light was already weak. In the American Southwest, you can normally get a good sunset shot around 1/125 at f/5.6. My incident light meter gave a reading for the castle of 1/60 at f/4.0, indicating a two-stop difference from what I expected.

Peak moments in natural light can be very fleeting. Within thirty minutes the "sweetlight" on this castle was gone. Sometimes even seconds can make the difference. By the time you think about shooting, it may be too late. So shoot first and think later.

TECHNICAL DATA: Mamiya RZ 67, 110mm normal lens, 1/60, f/4, Fujichrome Velvia, tripod.

East coast and midwestern forests often block the light from the setting sun, making it difficult to take advantage of the beautiful golden light and long shadows. But if you can find stands of trees that are less densely packed together, the sun streaming through foliage creating backlighting makes a great shot.

This picture was taken in Merchant's Mill Pond State Park in North Carolina. I was paddling a canoe through the eerie swamp of cypress and tupelo trees, watching the changing compositions as I drifted slowly. Shooting from water is difficult; you can't use a tripod, so you have to use a faster shutter speed with the corresponding loss of depth of field. It's hard to remain in the exact same position due to the water currents. Sometimes you can't place the sun peeking out from behind a particular branch or tree trunk because a slight movement of the canoe or boat means the sun is no longer in the same spot in the frame.

Due to the high humidity in the American South, the intensity of the low sun is diffused and softened, and the light level is quite low. I had to shoot at an uncomfortably slow shutter speed without a tripod *and* try to determine a light reading as the sun switched from brilliant to dim light when it slipped behind a branch. I couldn't find any reasonable medium gray in the frame for a reflective reading, so I finally resorted to the Sunny f/16 Rule and read the light as 1/60 at f/4.5.

TECHNICAL DATA: Mamiya RZ 67, 50mm wide angle lens, 1/60, f/4.5, Fujichrome Velvia, hand-held.

Including the sun in your composition is a powerful artistic tool. Use a telephoto lens to make the sun appear huge in comparison to a foreground silhouette. Or you can use a wide angle lens, used here, to make the sun look like a small star. In fact, any point source of light can be turned into a star *without* using a filter simply by using a wide angle lens and a small lens aperture—in the range between f/11 and f/22.

This photo was shot in Organ Pipe Cactus National Monument in southern Arizona. I spent most of the late afternoon looking for cacti with attractive shapes to photograph against the sun. Just before the sun touched the horizon, I positioned the camera so the brilliant light shone between two arms of the giant desert plant, quickly took a meter reading and made the shot. At

this time of day, the sun seems to move very quickly. You will discover that you've got to shoot very fast or it will move behind another element in the frame, and you'll have to readjust the tripod position.

The light reading was taken from the blue part of the sky (away from the sun) with a hand-held reflective light meter. I could have used an in-camera TTL meter with the same results. An incident meter, however, would not have worked in this situation because the light falling onto my position—where I would hold the meter—was different from the light in the western sky.

TECHNICAL DATA: Mamiya RZ 67, 50mm wide angle lens, 1/4, f/16, Fujichrome Velvia, tripod.

Twilight

Don't put your camera away just because the sun has set and night approaches. The waning ambient light offers a unique opportunity to make many exciting pictures of both landscapes and cityscapes at a time when most other photographers are having dinner.

There is a narrow window of time between sunset and night, twilight, when the sky turns a deep cobalt blue. In temperate latitudes, this window lasts perhaps ten to fifteen minutes before the sky becomes black. Photographs taken during this brief period capture dramatic bluish purple skies contrasted with dark forms on the land or city lights. If you start shooting before the sky turns that rich cobalt blue, the long exposure required for twilight shots will overexpose the sky, and it will lose the rich deep bluish purple color. If you shoot after the cobalt has darkened to black, the sky won't have the contrasting hues that make twilight photos so striking.

The correct exposure for capturing both the twilight sky and the lights of a city is a long one. For medium speed film, in the 50 ISO range, I have learned that the best results are obtained from using a ten-second exposure and an aperture between f/4 and f/5.6. If the city lights are bright or you are close to them, I suggest f/5.6. If the city lights are far away or not very brilliant, use the larger aperture of f/4. There is a great deal of latitude during twilight photography, so you may actually like the results from both apertures. Latitude refers to the film's ability to produce an image with an acceptable exposure within a one or two f/stop range. In other words, a twilight exposure could look good at *both* f/4 and f/5.6. If you are shooting faster film, simply calculate the adjustment as follows (based on a ten-second shutter speed): ISO 100, f/5.6 to f/8; ISO 200, f/8 to f/11; and ISO 400, f/11 to f/16.

The ten-second exposure brightens the scene so it appears as if it were taken under an overcast sky during daylight hours. The big difference, however, is the bluish purple color that saturates every tree, building and rock in the composition. Winter landscapes are especially dramatic because the white mantel of snow takes on the colors of the twilight sky.

At twilight, there will be a mix of artificial and natural light that is the key to making these shots spectacular. Tungsten lighting is rendered on film as yellowish, fluorescent and mercury vapor lights as blue-green, and sodium vapor lamps as yellow-orange. When these colors mingle with the deep blue, natural light, the combination is very dramatic.

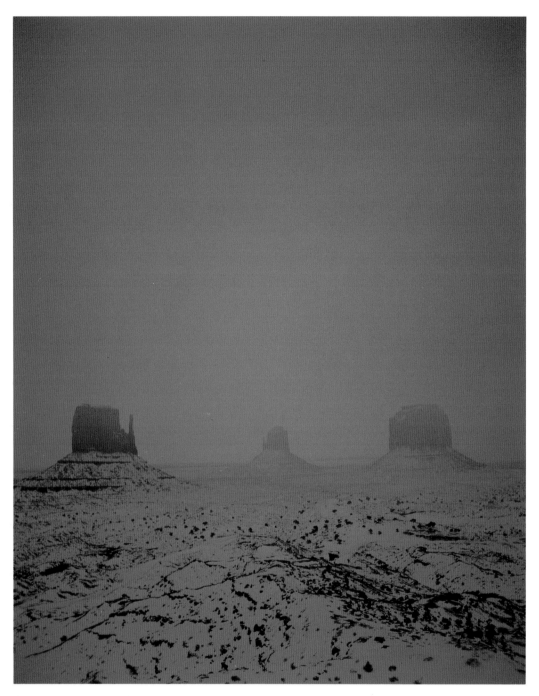

One of my goals in writing this book was to increase your awareness of the many subtleties of natural light. At no time are these subtleties more apparent than at twilight. From minute to minute, the waning light changes in color and intensity as it becomes increasingly diffused and directionless. In addition, atmospheric conditions frequently change as the temperature drops. Low clouds will descend even lower, and rain turns to snow. In extreme cold, water droplets suspended in the air freeze and fall to the ground, making the sky crystal clear.

This view of Monument Valley taken during a winter storm illustrates one of the more somber moods of twilight. (See the photo of the New York City skyline on page 83 for a different mood.) The last bit of daylight and the gloom cast by the low cloud cover produce a monochromatic, low contrast image. Because the ambient light was so dim and I wanted to lighten up the scene a little, I doubled my standard twilight exposure time for this picture. The monochromatic coloration of this landscape permitted the additional exposure time without any negative consequences. If there had been an illuminated monument or building near the camera position, it would probably have been overexposed.

TECHNICAL DATA: Mamiya RZ 67, 110mm normal lens, twenty seconds, f/4, Fujichrome Velvia, tripod.

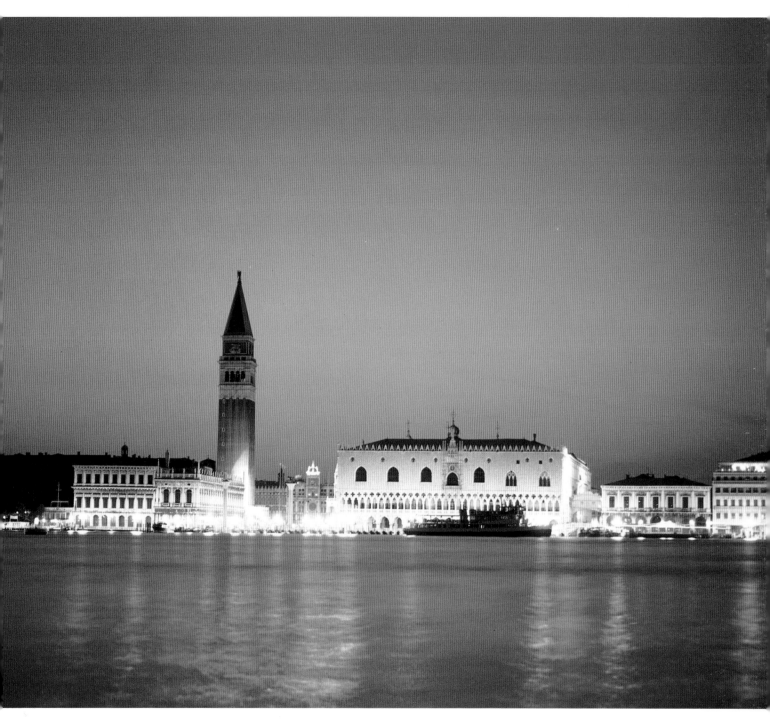

Some photographers don't like the greenish blue cast of mercury vapor lights and fluorescent fixtures. The simple way to eliminate these garish hues is to use a correction filter that shifts the color back toward a more normal range. Since a filter covers the whole lens, you will alter all of the colors in the image.

This shot was taken from St. George Island looking back at San Marco Square in Venice, Italy. The FLD filter I used was magenta, which is the complement of green on the photographic color wheel. This means that the magenta glass of the filter neutralized the greenish light. (Mercury vapor and fluorescent lamps produce a light that appears white to the eye but registers as a green or greenish blue on film.) The buildings are now illuminated by a neutral, white light. However, the sky has changed from the cobalt blue I saw, to a brilliant magenta because the filter affected all the colors in the image, not just the green light.

The light loss caused by the FLD filter is approximately two-thirds of an f/stop. The increased exposure time to compensate for this is really insignificant, because the camera must be mounted on a sturdy tripod for twilight photography anyway. As long as there is no strong wind that might buffet the camera, the longer exposure won't impact the quality of the photo.

TECHNICAL DATA: Mamiya RZ 67, 250mm telephoto, sixteen seconds, f/4.5, magenta FLD filter, Fujichrome Velvia, tripod.

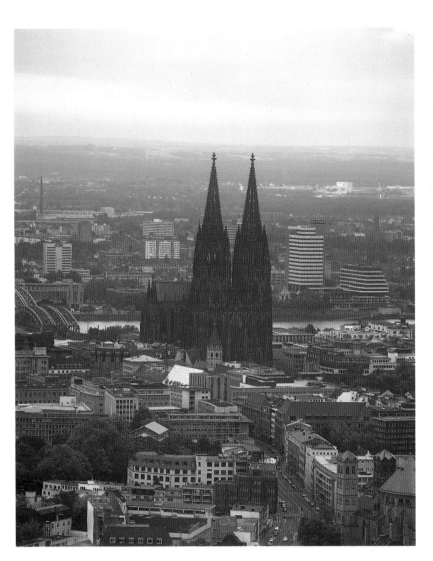

Many industrialized cities are shrouded by haze or smog that make daylight photography a waste of time. A gray-brown sky produced by these conditions is so unattractive that it ruins the entire photograph. When I need to capture the beauty of such a location, I know that, no matter how bad the atmospheric conditions are, I can always wait until twilight. Even a dismal sky will look good just before dark.

This view of Koln, Germany was first taken on a hazy day with unattractive lighting. The famous cathedral sits majestically beside the Rhine River. It appears dark gray and black due to centuries of natural weathering and airborne industrial wastes. Even Fujichrome Velvia, noted for its ability to produce intensified colors, couldn't do anything to enhance this shot.

TECHNICAL DATA: Mamiya RZ 67, 350mm APO telephoto lens, 1/30, f/5.6, Fujichrome Velvia, tripod.

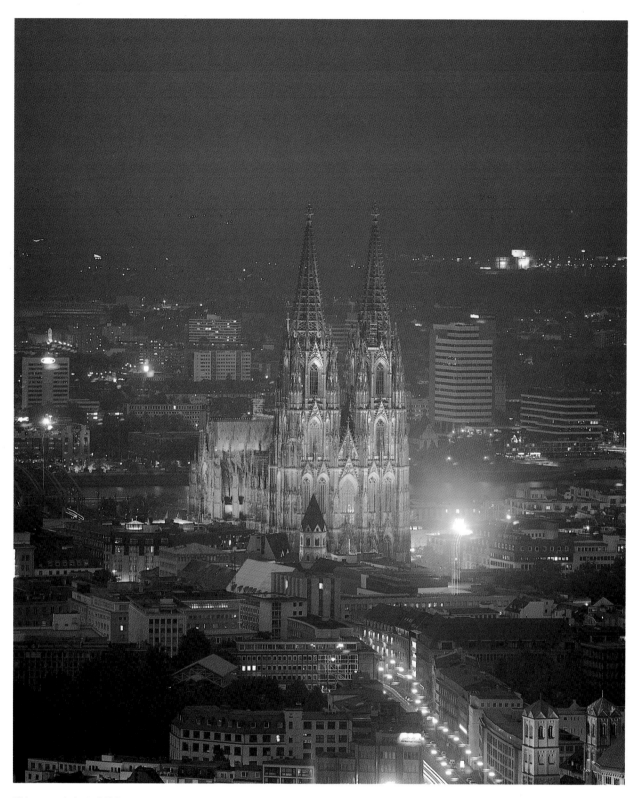

This second shot of Koln was made during that narrow window of opportunity at twilight, just ten or fifteen minutes before dark. Darkness had transformed the sky from gray to dark blue, although the lights of the large city diffused the color, keeping it from becoming a true cobalt blue. The mercury vapor lights shining on the cathe-

dral were recorded by the daylight film as a greenish blue color. The building no longer looks dingy; it now appears as an emerald fantasy of Gothic architecture.

I took both the daytime and twilight shots through a window in a tower several blocks from the cathedral. I placed the lens shade up against the glass and used it to

block any extraneous interior light from reflecting back from the window into my lens.

TECHNICAL DATA: Mamiya RZ 67, 350mm APO telephoto lens, ten seconds, f/5.6, Fujichrome Velvia, tripod. No filter was used to create the color or to correct for mercury vapor lights.

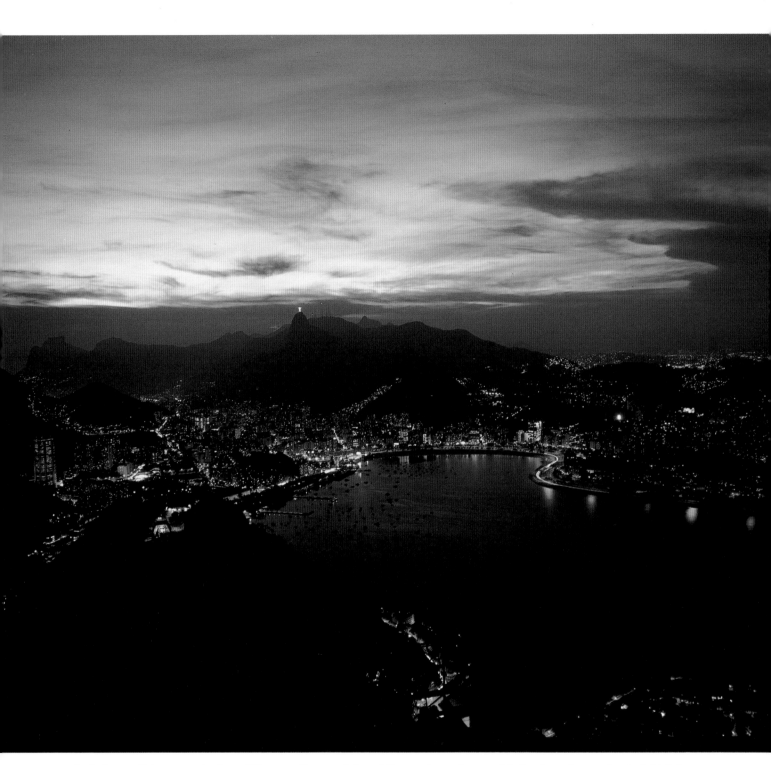

Both these twilight panoramic shots of Rio de Janeiro were taken from Sugar Loaf Mountain within minutes of each other. Why do they look so different? The shot on this page was taken with a daylight film, Fujichrome Velvia. The shot on the facing page was taken with a tungsten film, Fujichrome 64T.

Tungsten-balanced films produce colors that appear correct to our eyes when used in conjunction with tungsten bulbs. The lighting in our homes and offices, with the exception of fluorescent tubes, is tungsten. If tungsten balanced film is used outdoors in daylight, everything in the picture will have a strong bluish cast that overrides the original colors. Conversely, daylight balanced film produces yellowish tones when used indoors with tungsten bulbs.

TECHNICAL DATA: Mamiya RZ 67, 50mm wide angle lens, ten seconds, f/4.5, Fujichrome Velvia, tripod.

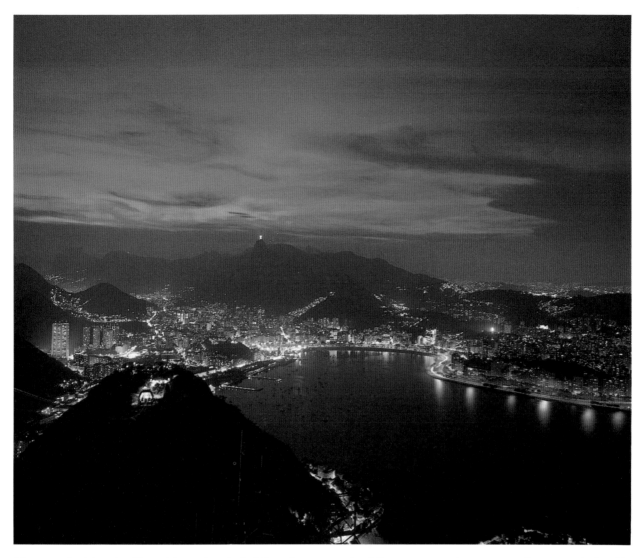

When you shoot tungsten film outdoors at twilight, the dominant bluish cast seen in daylight photos is evident. It colors the early evening sky and the city lights. Notice, however, that the colors are not monochromatic; subtle mauve and purple hues mingled with the blues were captured by the Fujichrome 64T. (When I shot the same vista with Kodak's tungsten film, Ektachrome 50T, however, I was disappointed to find the colors came out a dull, monochromatic blue.)

The wind was howling at the top of Sugar Loaf Mountain when I took these pictures. When you make long exposures, you may have to weight the camera and tripod down with a sand bag or other, more convenient object. Sometimes I'll hang my photo backpack on a tripod knob. If you have nothing that will work, exert a firm, downward pressure on the camera body with your free hand during the entire exposure. Be careful not to inadvertently jar the camera. You should also use your body to block the wind from striking the camera/tripod assembly as much as you can.

TECHNICAL DATA: Mamiya RZ 67, 50mm wide angle lens, ten seconds, f/4.5, Fujichrome 64T, tripod.

One of the first things I do when I'm shooting the scenic highlights of any city, whether foreign or domestic, is to study postcards in book stores or gift shops. In most cases, a beautiful monument or building that is illuminated at night will be featured on a card. This tells me at a glance where the best twilight subjects may be. I will also ask local citizens what well-known local sites are dramatically lit at night. A ride or walk through the heart of the city, which usually takes me about a half-hour, helps me find the best photographic possibilities.

This magnificent temple complex in Yanagon, Myanmar (formerly called Rangoon, Burma), is called Schwedagon. It dominates the city both day and night. High-intensity beams illuminated the top of the giant stupa, the cone-like structure that comprises the temple. The mixed light—mercury vapor, fluorescent and tungsten—combined with the cobalt blue sky to create the wild combination of colors you see here. The colors of the ancient architecture are brilliant in daylight, but the blend of surreal lighting at twilight and the fanciful design of the temple makes a stunning shot.

TECHNICAL DATA: Mamiya RZ 67, 50mm wide angle lens, ten seconds, f/5.6, Fujichrome Velvia, tripod.

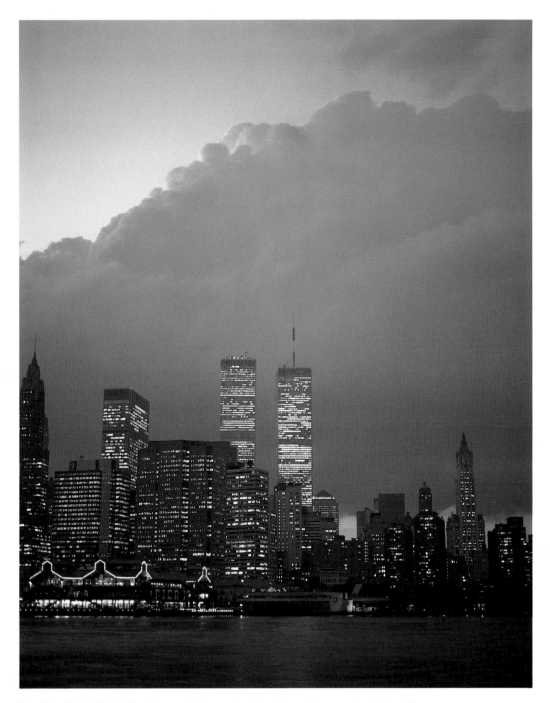

The New York City skyline is one of the great, man-made wonders of the world. As the city's lights gradually come on during the early evening, millions of sparkling diamonds seem to appear everywhere. It's one of the most dazzling sights anywhere.

The sky in this picture is not the typical cobalt blue color characteristic of twilight. I made the photo well before darkness descended on lower Manhattan, while mauve hues dominated the sky. My long exposure brightened the tones in the clouds and sky; the ambient light level above the city was much darker than it appears here. I chose to take the picture early—before the narrow window of photo opportunity called twilight—because the cloud formation was especially dramatic. I was afraid that I would lose the mood if I waited another fifteen minutes or so.

When shooting this type of scene, wait until there are enough lights on to make a powerful statement before taking the shot. If there are only a few lights showing here and there, the photo will have little impact.

TECHNICAL DATA: Mamiya RZ 67, 250mm telephoto lens, ten seconds, f/4.5, Ektachrome 64, tripod.

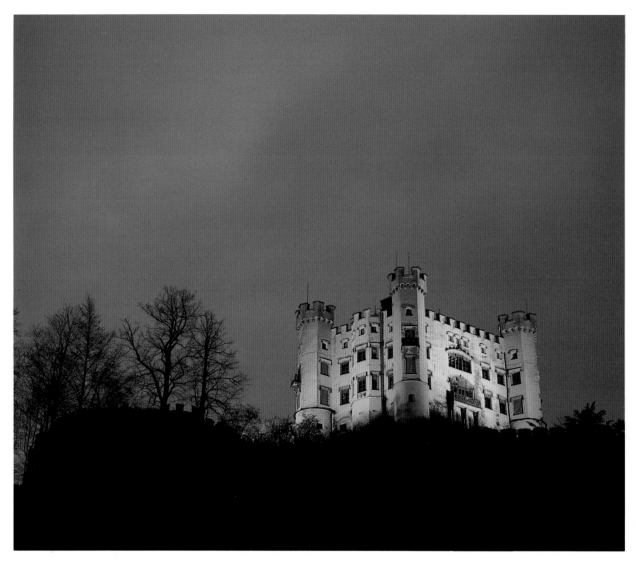

It is not necessary for the sky to be clear in order to attain that beautiful, cobalt blue color. Many of my best twilight images have been taken under overcast skies.

I photographed Hohenschwangau Castle in Bavaria at the beginning of twilight. If I had waited another ten minutes, the sky would have been darker and, therefore, a deeper blue color. When I took this shot, it was still light enough to see the tonal gradation in the clouds that I wanted to capture.

The intense yellow illumination on the castle comes not from tungsten lighting but from sodium vapor lights, which produce a saturated, yellow hue. The intensity of the yellow color is captured on film much as it is seen by our eyes. Compare this coloration with that produced by mercury vapor lights in the shot on page 85, where the light looks white but photographs a greenish blue.

Because of the long exposures, you must use a tripod for all twilight photography. I use a sturdy Gitzo tripod (model 323) or a Slik (The Professional II) with an Arca Swiss ball head that adjusts instantly to uneven terrain. The advantage of this type of tripod head is the ease and speed with which I can level the camera on any kind of surface. Most other tripods have two or three levers that take time to adjust properly. Instead, I have only a single knob to tighten. I use a locking cable release to trigger the camera with a bare minimum of vibration.

Virtually all of my nature, travel and people photographs are taken with very sharp, fine-grained film because I like brilliant detail and strong contrast. I will use faster films only when necessary. They show an increase in grain, a decrease in sharpness, and a decrease in contrast. Fujichrome Provia 100 is my second favorite film—after Fujichrome Velvia. With a magnifying loupe, you can see the subtle difference between the two films with respect to grain. The Provia 100 is slightly more grainy than the incredibly sharp Velvia. If you were to compare the Fujichrome films to Kodak's Ektachrome films, such as the EPR, EPN or EPP, you would note a dramatic increase in granularity. (Some photographers do like and regularly use the Kodak Ektachrome films for other aesthetic reasons, but I haven't been satisfied with those films. Kodak's Lumiere, however, is an extremely sharp-grained film.)

TECHNICAL DATA: Mamiya RZ 67, 250mm telephoto lens, ten seconds, f/4.5, Fujichrome Velvia, tripod.

The difference between a successful twilight photograph and one that has less impact can result from the amount of artificial light contrasted against the sky. The image above was taken in San Marco Square in Venice, Italy. It's not a bad shot, but it simply isn't as dramatic as the image to the right. The latter, taken in Seville, Spain, is more powerful because the brilliant yellow illumination from the sodium vapor lights is dazzling against the cobalt blue sky.

Notice also the difference in the sky between the two pictures. The shot in Venice was taken under a monochromatic low cloud cover. If I had made the Venice shot an hour earlier, when the lights weren't yet on and the daylight much brighter, the picture would have been a failure. The light was terribly flat, the colors were dull, and the sky would have been a large expanse of distracting whiteness. There's no question that shooting this scene at twilight was the best solution given the dull weather and flat light. However, compared to the photo in Spain, which was made with a clear sky, the picture of San Marco is second best. Although the Italian photo exhibits a purplish blue cast, it just doesn't have the intense color of the Spanish sky nor the gradation of tonality from light to dark.

I originally determined my exposure settings for twilight shots by bracketing in one-f/stop increments. My typical test for exposure was two, four, eight, sixteen and thirty-two seconds at one particular lens aperture. From those images, I decided which most accurately interpreted the scene to my liking. Sometimes, of course, atmospheric conditions will vary to such a degree that the familiar formula for exposure will be wrong. But a test of this type works well in most cases.

TECHNICAL DATA: Venice shot—Mamiya RZ 67, 50mm wide angle lens, ten seconds, f/4.5, Fujichrome Velvia, tripod. Seville shot—Mamiya RZ 67, 50mm wide angle lens, ten seconds, f/5.6, Fujichrome Velvia, tripod.

I always look for places high above a city—perhaps a hill, the top of a building, a revolving restaurant or a high suspension bridge—from which to photograph a skyline, especially at twilight.

This panoramic shot of Frankfurt, Germany, was taken from a medieval church tower reached by climbing four hundred stairs. As twilight approached, and it grew darker, it became difficult to see where my equipment was. After I made this exposure, I turned too quickly and accidentally bumped one of the legs of my tripod. Because the observation deck was so narrow, I hadn't been able to spread the tripod's legs to their full width. The sudden jolt sent the camera/tripod assembly crashing toward the concrete. In the darkness, I didn't realize that I had hit the tripod hard enough to knock it over until I heard my camera strike the floor with a crash. My lens was badly damaged.

When you shoot at twilight, keep careful track of where you've placed your equipment. Keep a flashlight handy. I now leave my flashlight on, pointing down at the ground away from the camera and lens, so I will never again have this kind of accident. Also pay close attention to small and easily broken equipment. When you finish using a lens or filter, put it back where it belongs—always in the same place.

TECHNICAL DATA: Mamiya RZ 67, 110mm normal lens, ten seconds, f/4, Fujichrome Velvia, tripod.

The deep, cobalt blue color of this photo of Telluride, Colorado, was caused by natural phenomena, not a filter. At that time of day, the tail end of the ten to fifteen minute twilight window, the sky is always rendered on film as an exceptionally rich cobalt blue color. The white mantel of snow took on the color of the twilight, too.

I took this shot in the dead of winter. Snow covered the ground, and the low clouds added to the somber mood of the evening. I waited until just before dark to make the exposure because I wanted the maximum number of lights turned on. Since Telluride is a small town, there aren't that many lights to begin with. If I had waited another ten or fifteen minutes, even more lights would have been on, but the sky would have appeared black instead of bluish purple in the photo. The definition of the mountains against the clouds would also have been lost in the blackness.

I spent time driving around Telluride to find the best vantage point for an elevated view. I had to hike up a pathway on the mountains south of town, but I knew immediately that this was the perfect shot. I chose a normal lens because a wide angle encompassed too much; it made the town seem too far away. A telephoto eliminated the mountain range and took Telluride out of its context.

TECHNICAL DATA: Mamiya RZ 67, 110mm normal lens, ten seconds, f/4, Fujichrome Velvia, tripod.

Overcast Conditions

Many who have participated in my workshops and seminars express disappointment when shooting outdoors on cloudy days. When the sky is overcast, they believe they have to put their cameras away. They are wrong, but it often takes a lot of convincing to get them to try some shots. Once the film is developed, they're astonished by the great photographs.

I hope you won't be as hard to convince that many beautiful pictures can be taken when the light is soft and diffused. A studio photographer uses a soft box or umbrella with a flash head to produce soft, flattering light without contrasty shadows or strong texture. You can get the same results simply by taking a photograph outdoors on an overcast day or placing your subject in the shade or a shadow. (It will cost you much less, too.)

Outdoor portraits and many other types of shots can actually be more effective, when made under a white, overcast sky. You won't have harsh shadows on a face, and your subject won't be squinting at you. If the sun is shining when I'm photographing people outdoors, I often ask them to step into the shade to simulate an overcast sky. When shade isn't available, I've used diffusion panels to soften the sun's light until it's similar to that on a cloudy day. The whole point of going to this kind of trouble for diffused light is to make your subject look more attractive. When the sky is white, nature has saved you the trouble of using awkward equipment to achieve the same effect.

Please be aware that very few photographs look good when you *include* the overcast sky in the composition. A blank, white portion of the frame is distracting. It takes the viewer's attention away from the significantly darker subject, because people always look at the brightest part of a picture first. If that part is uninteresting, the photo loses impact. (Including a white sky is as bad as having a background that's brighter than your subject, causing your subject to be subordinate.) So, when you use overcast conditions to provide a diffused light source, don't include the sky itself.

Some complain that colors are muted on overcast days. One way to solve that problem is to use a color saturated film. I choose Fujichrome film for virtually all of my shooting (as you can see from the captions in this book) because I prefer rich, deep colors in my images. Fuji's philosophy is to produce a film that will give you saturated color. Kodak's approach is to render a scene as close as possible to reality.

Fujichrome Velvia—rated at ISO 40, the true speed of this emulsion—is the most color saturated film I've used. At the same time, it is extremely sharp and fine grained. Fujichrome Provia 100, a favorite film for shooting wildlife, gives additional speed with little increase in grain. The colors are not as intense as Velvia, but they are still exceptional. Fujichrome 50D is an excellent film for photographing people or wildlife, but it doesn't have the speed that will allow you to use the faster shutter speed that may be necessary under certain circumstances. Fujichrome Provia 400 is a lifesaving, fast film in conditions too dark for Provia 100, especially when photographing subjects that are moving. It is definitely more grainy than the slower films, but the grain structure is still excellent for a fast film. Fuji's tungsten film, 64T, has brilliant colors and fine grain.

Kodak's Lumiere is an extremely sharp film with colors more on the warmer side. It can be used with excellent results for portraiture—skin tones are superb—but, in my opinion, it doesn't have the punch for landscapes, flowers, wildlife and cityscapes. The Kodak Ektachrome films, such as EPP, EPN and EPR, are noticeably more grainy than either Lumiere or Fuji's Velvia and Provia films. Although other photographers are happy with the results they get from Ektachrome films, I don't use them. After using Kodak's tungsten films for years, I now feel they don't compare in color saturation to Fujichrome 64T.

Some subjects are best photographed in overcast conditions. Glacial ice, for example, is bluish in color when shot under a direct sun, but when a cloud cover softens the ambient light, the intensity of the blue is much deeper. When the ice is composed with a white sky—one of the rare circumstances when a white sky can be included in a composition without distracting the viewer—the color of the ice is intensified.

I took this shot south of Anchorage, Alaska, at the Portage Glacier. I had seen the area under a blue sky on a previous trip and was much less impressed than when seeing it under a low cloud cover. The float-ing chunks of blue ice contrasted vividly with the gray and white environs. I felt that I was shooting art in nature.

I chose a telephoto lens to isolate a small portion of the landscape. There were many elements in the scene that would have confused the composition if they were included in the frame. The narrow-angled lens eliminated the unwanted portions of ice and water to make the shot perfect.

I exposed the scene with a hand-held incident meter, a Minolta Flash Meter IV that reads both flash and ambient light. You can use an in-camera TTL meter in this situation only if you take the reading from a neutral toned subject, such as a gray card or a gray or beige camera bag. You would then have to set the shutter and aperture manually, since using the automatic exposure mode would replace the correct reading with what the meter registered when you pointed it toward the scene again. If you use an incident meter, both it and your subject must be in the same light. With a reflective meter, the neutral-toned object must be in the same light.

TECHNICAL DATA: Mamiya RZ 67, 360mm telephoto lens, ½ second, f/16, Fuji-chrome Velvia, Minolta Flash Meter IV, tri-pod.

The photographer in a studio who wants an even distribution of light uses a large soft box or umbrella with a flash head. You can achieve the same effect outdoors, even on a sunny day, by placing your subject in the shade of a large tree or a building.

I found these dolls' heads piled up in a basket in a Bangkok doll factory. After asking permission to set up a photo, I took them outside to get away from the factory's harsh fluorescent illumination. I would have preferred an overcast, white sky for diffused light, but the sun shone brightly in a blue sky. So, I used the shadow cast by the building to give me the type of lighting I wanted.

When doing macro work, keep the film plane as parallel as possible to the subject to provide the maximum depth of field at the selected aperture. The dolls' heads were arranged in the top of a shoe box I had laid on the ground, so I placed my camera directly above the faces with its back parallel to the ground. Had the film plane been oblique to the dolls' heads, I might not have been able to achieve complete depth of field, even with a small f/stop.

TECHNICAL DATA: Mamiya RZ 67, 127mm lens, #2 extension tube, two seconds, f/22, Fujichrome 50D, tripod.

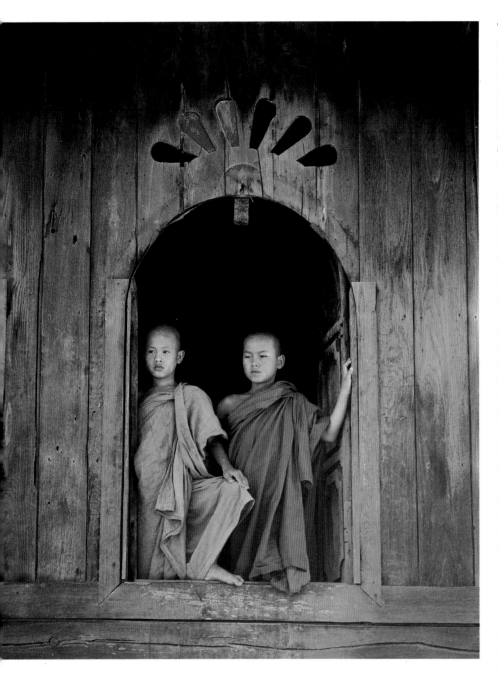

This photo clearly illustrates the advantages of shooting people in diffused rather than direct light. The young novices were peering out of a monastery window near Inle Lake in Burma. The diffused ambient light brought out all the neutral tones of the wooden structure as well as emphasizing the boys' skin tones. The warm colors of their robes create a subtle contrast to the cool, gray-colored wood.

If the sun had been shining, the subtle tonal variations would have been replaced by harsher contrasts of light and shadow. Direct sunlight, especially if the sun were high in the sky, would create dark shadows on the boys' faces and in the folds of their clothing. The bright, harsh light would also have caused the novices to squint, closing their eyes even more than they are now.

The window was on the second story of the monastery. This meant that I had to shoot upward from ground level. When you can't keep the film plane parallel with your subject, in this case the monastery wall, depth of field is reduced and keystoning results. This means that the vertical lines of the building will appear to angle inward. (Keystoning is often seen in shots of city skylines, where the skyscrapers appear to lean inward.)

To minimize this unwanted effect, I avoided shooting upward with a normal lens. I stepped back about thirty feet and used a telephoto lens instead. The film plane of the camera was now more parallel with the wooden wall, so the wood slats were almost parallel with the camera's viewfinder. I couldn't make the film plane and the wall exactly parallel unless I shot from a higher vantage point (and I didn't have a ladder) or stepped back further. I couldn't go back more than I already had, or the sky above the monastery would have been included in the frame, where it would have detracted from the rest of the shot.

TECHNICAL DATA: Mamiya RZ 67, 360mm telephoto lens, 1/60, f/6, Fujichrome 50D, tripod.

Indirect, diffused light is ideal for photographing people in street clothes or dazzling carnival costumes, as shown here. The soft light eliminates the harsh shadows typically caused by the midday sun, creating an attractive image during what is often a poor time to shoot.

Highly reflective subjects, such as this gold mask, often cannot be photographed effectively in contrasty lighting. The metallic surface of the mask would reflect the sun into the camera, adversely affecting the meter reading and destroying the subtle variations in the reflections. Using diffused light would be the best way to shoot this portrait.

I asked my model to move into the shadow of a building, where the light would be soft and diffused. I made certain when I composed the shot that the background was receiving approximately the same light as my subject by reading both areas with a spot meter. Had the background been illuminated by direct sunlight, it would have been overexposed and drawn attention away from the darker subject. Because the eye is drawn to the brightest area of picture first, try to always have your subject much lighter than the background. (For a different approach to taking a portrait, see page 47, where I used the harsh light of the midday sun to create a specific effect.)

TECHNICAL DATA: Mamiya RZ 67, 110mm normal lens, 1/125, f/2.8, Minolta Spot Meter F, Fujichrome Velvia, tripod.

Even soft, muted light is directional. It was overcast the day I took this portrait of a boy and his dog in Salobrena, Spain, but the light on his face appears to be coming from the side. The building was actually blocking some light from one side of the boy while the other side was open to the white sky. A subtle light ratio, where one side of a face is brighter than the other, adds dimension to an image. The direction of light can be manipulated with respect to a subject simply by turning the angle of a face or a body.

Environmental color can also affect an image. The blue paint on the building is reflected into the darker portion of the boy's face and on the dog's hair. It's not blatant, but you can see the cool tones influencing the color of the skin and hair.

My medium telephoto lens, the 250mm, is comparable to a 135mm in 35mm format—the classic focal length for portraits.

TECHNICAL DATA: Mamiya RZ 67, 250mm telephoto lens, 1/60, f/4.5, Fujichrome Velvia, tripod.

Muted light is as attractive on animals as it is on people. Unfortunately, you can't ask a wild animal to hold a pose. That means the longer exposure required in diminished light may produce only a blurred shot when your subject suddenly moves.

This Canadian lynx was photographed in the understory of a dense forest, the typical habitat for these stealthy cats. The light conditions of the cloud cover were exacerbated by the thick foliage. I had to push the Fujichrome 100D I was using to ISO 400, a two-stop push, in order to have a fairly fast shutter speed, even though pushing film increases grain and lowers contrast. (Always remember that you can't push just a few frames; you must push the entire roll.)

My tripod steadied the large Mamiya camera, and the Arca Swiss ball head let me quickly level the camera despite the uneven ground.

TECHNICAL DATA: Mamiya RZ 67, 500mm APO telephoto, 1/125, f/6, Fujichrome 100D pushed to ISO 400, tripod.

Interstadial stumps are remnants of trees buried by glaciers for centuries and then uncovered when the ice sheet receded in warmer years. I found this one rising out of a stony shore line in Glacier Bay National Park in Alaska. The beautiful design in natural wood, once a living tree, is approximately six thousand years old. The shells embedded in the wood were forced into it by the pressure of tons of ice.

I didn't use a filter to create this photo. Most cloudy days produce transparencies that are cool or bluish in tone. Shooting under a heavily overcast sky produced the deep blue tone of the photograph. The dense cloud layer filters out much of the red portion of the color spectrum, permitting primarily the shorter wave lengths, i.e., blue light, to penetrate to the earth. This particular image is so blue because the day was exceptionally dark.

Even when the weather is depressing, and you don't seem to have a prayer of taking a good, much less a great, photo, don't give up. Move in close, look for subjects with interesting graphic shapes, and compose pictures that don't require spectacular lighting to be successful. Muted light can be the necessary ingredient for a unique and interesting image, as it is here.

TECHNICAL DATA: Mamiya RZ 67, 110mm normal lens, two seconds, f/32, Minolta Flash Meter IV, Fujichrome 50D, tripod.

I've taken many of my favorite landscape photographs at sunrise and sunset, but I took this one under a very overcast sky. In fact, it was drizzling slightly when I made the exposure.

A dull, white sky hung above the cliffs that surrounded the waterfall. I eliminated the unattractive sky from the scene in my frame, so the whiteness wouldn't compete with the more subdued, earthy tones of the mountains, the green foliage and the blue

water for the viewer's attention.

Sometimes you can improve the scene you see without resorting to filters or artificial light. Notice how saturated the colors appear in this photo; the landscape actually looked much darker than it does here. The reading from my hand-held incident meter was ½ second at f/32. If I had used that combination, the resulting transparency would have looked exactly like what I saw. Instead, I compensated for the drab light

by opening the lens aperture to f/22 and one-third. This two-thirds f/stop increase in exposure brightened up the picture. An additional benefit of the longer exposure was the increased blurring of the rushing water, an attractive effect.

TECHNICAL DATA: Mamiya RZ 67, 50mm wide angle lens, ½ second, f/22 plus 1/3, Fujichrome 50D, tripod.

Romer Square in Frankfurt, Germany, is one of the few remnants of the old city that survived the intense Allied bombings of World War II. The prewar architecture provided me with a classic European design.

A scene with bright sun and a blue sky sells a travel destination to the viewer, so that's what I prefer to send to Westlight, my stock photo agency. However, many places are frequently shrouded by overcast skies. The undesirable light quality forces me to look for graphic details and colorful patterns that will define the locale but look good under the soft, diffused light. Although many colors appear dull to the eye under cloudy conditions, they will still photograph beautifully, especially with Fujichrome Velvia, which I expose at ISO 40, or Fujichrome Provia 100, which I expose at ISO 100.

Note that I totally eliminated the sky from this shot by lowering the angle of my lens until the composition was completely filled with the architecture. I wanted to avoid having a brilliant white strip at the top of the frame vie with the pattern of the windows for the viewer's attention. The dif-fused light from the sky provided shadow-less illumination on the facade. I used a small lens aperture for increased depth of field. Because the camera was angled slightly upward, the film plane was not par-allel with the building exterior. The loss of depth of field would be subtle, but it might be enough to detract from the pattern. I thought f/22 would compensate.

TECHNICAL DATA: Mamiya RZ 67, 360mm telephoto lens, ¼ second, f/22, Minolta Flash Meter IV, Fujichrome Velvia, tripod.

Diffused natural light can occur at any time. Many times I've gotten out in the pre-dawn darkness and set up my camera, hoping for a glorious sunrise, only to be disappointed by clouds blocking the sun. In those instances, the only alternative to going home empty-handed is to look for subjects complemented by the low, soft light.

The early morning frost on the ground in the mountains above Olympic National Park in Washington offered me some com-

pensation for the sunrise shot I couldn't get. Macro photography almost always works well in diffused light, so I searched for an appropriate subject. I pointed my camera straight down toward this plant and carefully avoided including the uninteresting rocky soil surrounding it.

When taking close-ups in nature, depth of field is a serious problem. The small apertures make long exposures necessary. When you crank a macro lens out to its

maximum magnification, or use extension tubes or bellows, light is lost and very long exposures are required to compensate. This means you must shoot subjects that don't move. Even the air must be perfectly still, because the slightest breeze will disturb leaves or flowers enough to make it impossible to get a sharp picture.

TECHNICAL DATA: Mamiya RZ 67, 110mm normal lens, #1 extension tube, one second, f/22, Fujichrome 50D.

Under overcast conditions, when the sky is white, it's difficult to determine the correct exposure with an in-camera meter in averaging mode for a subject much darker than the sky. When you want to include white snow in the composition too, you've given yourself a real challenge. You can accurately determine the exposure with a hand-held spot meter or your in-camera meter in spot mode, or you can take an average reading on a neutral toned object, such as your blue jeans. An incident meter may be the easiest and fastest tool for the job how-ever, since it reads the light falling on the scene and is unaffected by the white sky or snow.

When you're photographing wildlife, time is of the essence. While you're trying to determine the light reading, an animal can disappear into the forest before you take a single frame. Therefore, it's best to set the camera's shutter speed and aperture settings before the action begins. Overcast skies don't change quickly, and you may be able to use the same light reading for hours. Just check the reading frequently, and you'll be prepared for those few, brief moments when an animal appears.

I baited this red fox to the tree by placing raw meat in the bark. Since I had taken my light reading well before he arrived, all I had to do was focus and shoot. The color of the fox's coat appeared especially luminous because the snow on the ground acted as a reflector and bounced light from the sky into the red hair.

TECHNICAL DATA: Mamiya RZ 67, 350mm APO telephoto lens, 1/125, f/5.6, Fujichrome Provia 100, tripod.

At higher elevations a low cloud cover often means dense fog. You're virtually inside the cloud. That was the case when I was trying to photograph this stand of trees on the slope of Mt. Ranier in Washington. Tonal values were bluish due to the low contrast, ambient light.

Because the moisture particles reflecting light back at the lens appear much brighter than the trees themselves, an in-camera TTL meter won't give you an accurate reading. The meter will interpret the scene as being so bright that a decreased exposure is needed to compensate. In the resulting image, the whiteness will be incorrectly darkened to a medium gray. Use a hand-held reflective meter to read a middle-toned object instead in order to get the correct exposure. I had just used my gray backpack to get a correct meter reading when a bald eagle flew through the scene. I waited until he was positioned nicely in the frame before I took a single shot.

TECHNICAL DATA: Mamiya RZ 67, 250mm telephoto lens, 1/250, f/5.6, Fujichrome Provia, tripod.

The famous golden doors of the Baptistery in Florence, Italy are covered with many scenes from the Bible. Any richly detailed artwork is best photographed under diffused light. When the piece has tremendous depth, as does this interpretation of a Biblical scene, soft light is especially important. Harsh shadows cast by a direct sun can easily destroy the richness of the artwork, creating unwanted shapes that spoil the photo.

The Baptistery doors are very tall, perhaps twelve feet high. I chose to shoot a panel that was at eye level. If I had attempted to photograph one far above me, keystoning would have occurred at the sides of the panel. With the film plane of the camera parallel to the artwork, I made the exposure based on a reading provided by my incident meter. I didn't want to use a reflective meter, even if I read a neutral toned object, because I felt that might not give me the correct reading for the shiny, gold doors.

TECHNICAL DATA: Mamiya RZ 67, 110mm lens, ¼ second, f/16, Fujichrome Velvia, tripod.

At an October photo workshop in Acadia National Park in Maine, I had a group of people hoping to bring home dramatic, colorful images. In the dull, flat light of an overcast day, it was hard for me to convince them that we could get still some good shots. I took this macro shot to demonstrate how we could still get rich colors in the diminished light.

I arranged a red leaf on a fern lying on the floor of the forest. The day was gloomy

and, to exacerbate the problem, my composition lay at the base of a tree which cast a faint shadow on the ground. I chose this particular location because I liked the design in the fern.

I increased my exposure by one-third f/stop, from 1/15 at f/4.5 to 1/15 at f/4. This brightened the picture just enough to give it some life. I then extrapolated the exposure required for a smaller aperture that would increase depth of field—two seconds

at f/22. Then, I compensated one f-stop for the light loss in the bellows extension. I used a film, Fujichrome Velvia, that produces saturated, beautiful colors even on murky days.

TECHNICAL DATA: Mamiya RZ 67, 110mm normal lens with the built-in bellows fully extended, one second, f/22, Fujichrome Velvia, tripod. I could only have made this long exposure when there was no wind to disturb the leaf.

Interiors

Natural light is primarily an outdoor phenomenon, but it does enter man-made structures, illuminating interiors in fascinating ways. Large, cavernous buildings, such as Gothic cathedrals, are especially dramatic when natural light streams in through high windows or large, arched doorways. We should appreciate the beauty of natural light indoors and the techniques used in photographing with it.

When shooting indoors, we often have to deal with a mixture of natural and artificial illumination. This adds an exciting dimension to an interior. If you use daylight-balanced film, such as Fujichrome Velvia or Kodak Lumiere, the colors of the natural light will be properly reproduced on film. The artificial lighting, usually from tungsten or fluorescent bulbs, will contrast with the daylight, appearing yellowish and blue-greenish respectively. Tungsten-balanced film, such as Fujichrome 64T or Ektachrome 50T or 160T, will turn the daylight into a bluish cast, while the tungsten illumination is reproduced as our eyes see it. The fluorescent lights will still appear blue-green.

Large interiors lit solely by daylight are characterized by a wonderful interplay of highlights and shadows. Both the light and dark areas are many f/stops below the ambient daylight, but the lighting within is often exceptional. Shadows have unusual shapes, metallic objects reflect the contrasty windows, and beams of light can be seen in the relative gloom.

Flash photography is useless in a huge room. A single strobe head offers only flat illumination, and the distances are so great that a portable flash, such as a Vivitar or Sunpak, will probably have little effect on the ceiling. More importantly, however, a flash unit strong enough to overpower the existing light would destroy the dramatic interplay of shadows and highlights.

Due to the low light level inside many buildings, long exposures are needed, which require the use of a tripod. With a medium speed film the exposures usually range from one quarter second to one full second at f/4. I use a cable release and the mirror lockup feature to minimize vibration. The most challenging aspect of capturing the overwhelming opulence and beautiful decoration of many famous buildings is obtaining the correct exposure.

Taking a light reading in a huge room where natural light is entering windows near the ceiling, perhaps fifty feet above the floor, is problematic because the light at the camera position is several f/stops darker than it is at the windows. This means that you often can't use an incident meter, because the light falling on the meter must be identical to the light striking the portion of the interior that you're photographing. The TTL meter in your camera may give you a correct reading, but the contrasts between the deep shadows and brilliant sunlight may be greater than that kind of meter can gauge. If a bright window dominates the viewfinder, the meter reading could produce an underexposed photo. If a dark shadow dominates the viewfinder, the meter reading could produce an overexposed photo.

The best way to get a correct reading is to use a hand-held spot meter or your camera's TTL meter in the spot exposure mode. By reading a very narrow middle-toned (a medium gray value, halfway between black and white) portion of the composition, and using that reading for the shot, both the highlights and shadows will be rendered as accurately as possible given the extreme contrasts in the picture.

Shooting in your home is no different than in a large cathedral. The same considerations apply. If you choose to photograph family members or pets, you will most likely have to use fast film. The diminished light inside a building means long exposures. Ornate ceilings and marble columns don't move, but people and animals do. You can get away with a slow, fine-grained film only if your subjects can hold perfectly still.

This shot of a medieval Spanish cathedral was taken with a wide angle lens pointed straight up toward the ceiling. The windows near the ceiling permit the natural light to pour into the interior, but notice that much less light falls on the stonework in many parts of the picture. Some of the shadows are at least four f/stops darker than the illuminated areas. The stained glass windows, that actually are quite colorful and detailed, have been overexposed to the point of losing virtually all detail.

If I had exposed for the windows instead, the interior would have been grossly underexposed and much of the detail lost. You must decide with each shot what portion of the frame you want exposed correctly. In other words, which area should

equal the middle tones? Once you make that decision, the highlights and the shadows will fall into place. The specific area that is selected as middle-toned is an approximation of the midpoint between black and white. The color doesn't matter: it could be blue, mustard, purple or orange. As long as the tone is in the middle of the spectrum between light and dark, a reflective light meter will provide an accurate exposure. The area I chose for my reading in this picture illustrates this middle tonality.

I took the reading for this shot in the center of the frame, midway between the top of the column and the windows. I used a Minolta Spot Meter F, which is a one-degree spot. The narrow angle of the spot

meter allowed me to select a very small portion of the ceiling for the reading. A meter that encompasses too much of the frame may not be as accurate because unwanted shadows or highlights may be included in the reading. If you use a 35mm camera, a good approach to taking a spot reading would be to put on a telephoto lens, switch to the spot metering mode, and take the reading. Then, put the wide angle lens back on the camera body and manually set the f/stop-lens aperture combination from the spot reading for the actual shot.

TECHNICAL DATA: Mamiya RZ 67, 50mm wide angle lens, ½ second, f/5.6, Minolta Spot Meter F, Fujichrome Velvia, tripod.

The exterior of the Church of Santo Domingo in Puebla, Mexico, is unimpressive. But when you walk into the cool interior and enter the Rosary Chapel, the stunning beauty of the opulent gold leaf decorations and marble columns take your breath away.

The arched glass showcase containing a statue of the Virgin Mary reflected the windows high in the walls of the chapel. The natural light coming into the church was brilliant, yet the shadows in many of the vaulted alcoves were very dark. This extreme contrast made it challenging to get an accurate light reading.

My strategy for determining a correct exposure, given the wide range of light val-ues, was to find a middle-toned area from which I could take a spot reading. I used the center of the marble column closest to the camera. I felt that if the marble was exposed as a middle tone, then the other areas of the church would be rendered appropriately on film. I knew there would be too bright and too dark areas, however, because the contrast would exceed the film's latitude. In these situations, there's nothing you can do except expose for the middle tonal values and accept the results.

Film latitude is the ability of an emulsion to hold detail in a wide range of light values. Black-and-white film has more latitude than color negative films, and trans-parency films have the least latitude of all. At most, slide film can hold a five-f/stop range, i.e., two-and-one-half stops on either side of the middle-toned value. When the brilliance of the highlights exceeds that limit—as seen in the window reflection in this picture—detail is lost. The overex-posed white rectangle in the glass is the result of these highlights exceeding the film's latitude. The black shadows under the large arch at the edge of the frame were too many f/stops darker than the middle tones for any detail to be recorded on film.

TECHNICAL DATA: Mamiya RZ 67, 50mm wide angle lens, ¼ second, f/4.5, Ektachrome 64, tripod.

The three photos on these pages illustrate the choices photographers must make when we shoot with natural light indoors. Due to the limited nature of film latitude, especially with respect to transparency film, both brilliant highlights and deep shadows cannot be recorded in one shot without losing detail in one area or another. You will need, therefore, a compromise—the highlights will be somewhat overexposed, but still acceptable, while the shadows will be moderately underexposed, but still acceptable.

The subject is an interesting detail of the ceiling of the cathedral in Toledo, Spain. Natural light from the windows in the alcove illuminated the murals within the narrow confines of the recess in the ceiling. The paintings just below the alcove, however, received very little light. There was a five f/stop discrepancy between the two areas. In the shot above, I exposed only for the alcove. The murals in that portion of the frame are exposed correctly, but all detail was lost in the darker part of the ceiling. When I chose a compromise exposure for the shot at right, detail can be seen in both areas, but the highlights are very overexposed and the shadows badly underexposed. As you can guess from these two shots, exposing for the darker murals would

have caused all detail in the alcove to be lost in the overexposure.

TECHNICAL DATA: Top photograph—Mamiya RZ 67, 250mm telephoto, 1/8, f/8, Fujichrome Velvia, tripod. Lower photograph—Mamiya RZ 67, 250mm telephoto, ¼ second, f/5.6-f/8, Fujichrome Velvia, tripod.

This frame shows the paintings correctly exposed. To achieve this, I eliminated the extreme contrast from the composition by not including the brilliantly lighted alcove. I could then easily obtain a proper exposure of one portion of the ceiling.

You could use additional artificial light to balance the two areas so the darker area is brightened until it matches the well-lit alcove above it. This is, of course, not always possible or permitted. (Often artificial light cannot and should not be used because it can damage works of art, especially older pieces.)

TECHNICAL DATA: Mamiya RZ 67, 250mm telephoto, ½ second, f/5.6, Fuji-chrome Velvia, tripod.

It's challenging to shoot people in your home using natural light because the long exposures mean that the subject must remain absolutely motionless. I took advantage of the exceptionally brilliant decorator colors in my sister's home when I photographed model Rondi Ballard under a combination of natural and artificial light. Daylight entered the room from large windows, and an overhead chandelier provided tungsten illumination, giving the image warmth.

Because the light was evenly distributed, I could use any type of meter that was convenient. The Minolta Flash Meter IV, which is my favorite, gave me a reading of 1/8 at f/2.8. I used the Mamiya RZ 110mm normal lens because it offers the largest aperture in the RZ system. But even at f/2.8, the shutter speed of one-eighth of a second was too long to capture a sharp rendition of Rondi on the film, even though she was reclining and virtually motionless. Therefore, I pushed the ISO 50 film two f/stops to ISO 200 (50 to 100 is one f/stop, and 100 to 200 is the second f/stop). This allowed me to use a shutter speed of 1/30, two stops faster than 1/8.

Pushing the film tricks the meter into "believing" that the film is faster than it really is. This lets you use a faster shutter speed or smaller lens aperture. When you push film, it receives less exposure and, consequently, the image is underexposed. When the film is processed, it must remain in the developer longer than normal to bring out the underexposed image. Since the entire role of film is affected by the push processing, you must push the entire roll, not just one frame.

TECHNICAL DATA: Mamiya RZ 67, 110mm normal lens, 1/30, f/2.8, Fujichrome 50D pushed to ISO 200, tripod.

Shooting straight up in the beautiful Cathedral of Eger, an hour's drive from Budapest, Hungary, I captured the ceiling structure with the Mamiya 37mm fisheye lens (roughly comparable to an 18mm fisheye in the 35mm format). Fisheye lenses typically distort an image by bending vertical lines into curves. Subjects such as trees, columns and people are, for the most part, unattractive when bent into bizarre shapes. However, when you shoot a subject that is round already, the fisheye's distortion is virtually undetectable because adding curvature to a circle is meaningless. Here, the extreme wide angle view of the fisheye lens provides an interesting perspective without unpleasant distortion.

Shooting upward with a camera can be quite awkward. With the medium-format Mamiya RZ 67, I simply use the waist-level viewing hood that protrudes from the top of the camera body. When the lens is pointed toward the ceiling, the viewfinder is easy to see because it is at right angles to the lens axis. Some 35mm camera models have L-shaped, right-angle, prism finders. When the pentaprism is removed, the L-prism allows you to point the lens upward and still look in the viewfinder from the side. Otherwise, you've got to contort your back and neck to look under the camera. If you escape with only back and neck pains, you'll be lucky indeed.

I read the mustard color in the mural adjacent to the center of the dome with my spot meter to determine the correct exposure. I chose that portion of the composition to equal medium gray. (The term "medium gray" refers to a tonal value rather than to a specific color; medium blue or red could also equal a "medium gray" or middle-toned value.) The bright windows and shadowed arches then fell correctly into place, duplicating what I saw.

TECHNICAL DATA: Mamiya RZ 67, 37mm fisheye lens, ½ second, f/5.6, Fujichrome Velvia, tripod.

I used a fisheye lens to capture the vast expanse of the Galleria Vittorio Emanuele II in Milan, Italy. In this composition, however, the distortion of the fisheye lens is more apparent than in the shot of the Cathedral of Eger on the facing page. The sides of the Galleria curve toward the center, and you can see a curvature in the floor.

This shot was taken with available, but not natural, light. The greenish color comes from the building's mercury vapor lights, while the darkening sky can be seen through the glass dome. If I could have waited ten minutes to make the shot, the sky would have been a deeper cobalt blue.

Finding a middle-toned section of this subject wasn't easy. The sky I could see through the dome was too light, and I didn't trust the cold, white mercury vapor illumination to provide a reliable basis for a light reading. Any light that looks white but photographs green is just too weird to trust. I finally resorted to my tried-and-true method to determine the twilight exposure—ten seconds at f/5.6. It worked. (See page 53 for more on this method.)

During the ten seconds the camera was open, many people walked past the camera. Since they were constantly moving throughout the exposure, their forms blurred to such an extent that they disappeared.

TECHNICAL DATA: Mamiya RZ 67, 37mm fisheye lens, ten seconds, f/5.6, Fujichrome Velvia, tripod. No filters were used either to create the green color or to compensate for the mercury vapor lights.

The walls and ceiling of the Greek Orthodox Church of San Minas in Iraklion, Crete, are covered by paintings. The contrast between light and dark in this interior wasn't as severe as other churches I've shot in. A light reading using a TTL meter on the average exposure mode would provide an accurate evaluation in this situation, primarily because the light coming from the windows around the dome was counterbalanced by light entering the church from below. Huge doors opening onto the street allowed natural light to flood into the interior, so the lower portion of the ceiling was illuminated at approximately the same intensity as the figure of Christ in the center of the dome.

Although an averaging meter would have worked here, I still prefer a spot meter for absolute accuracy. I placed the one-degree spot on the cheek of the Christ to take a reading on the skin tone. This provided the middle-toned subject.

The long exposures necessary in dark interiors should be made on sturdy tripods. The ones that are made for travel are often very light and not trustworthy as firm supports. I always use a cable release to minimize vibration, and each shot is taken only after the mirror is locked up in the camera body. The elimination of the mirror's movement just before the exposure is one more thing you can do to ensure a sharp picture.

TECHNICAL DATA: Mamiya RZ 67, 50mm wide angle lens, ½ second, f/4.5, Minolta Spot Meter F, Fujichrome Velvia, tripod.

The beautiful Church of San Miniato al Monte in Florence, Italy, is illuminated by natural light, but there are also coin-operated tungsten lights. For about forty cents, visitors can have the lights turned on for two-and-a-half minutes to study in better detail the Renaissance murals.

The shot above, left, was taken with Fujichrome 64T, a tungsten-balanced film. The lighting on the ceiling is rendered in accurate color, since the film was manufactured to accurately reproduce subjects photographed under tungsten lights. However, the facade closest to the camera position received natural light from the high windows. It is rendered in a rich deep blue because tungsten film reproduces anything shot under white, daytime light in blue tones.

The photo above, right, was taken with the same lighting as the shot above, left, but it was taken with a daylight balanced film, Fujichrome Velvia. The tungsten illumination gives a yellow/orange cast to parts of the image, but the facade closest to the camera, in daylight, is now seen with the correct colors. (For more on film and color temperature, see page 53.) Because the tungsten film, ISO 64, is slightly faster than the Velvia, ISO 40, there is a one-half f/stop difference in the exposure.

TECHNICAL DATA: Photo above, left—Mamiya RZ 67, 110mm normal lens, one second, f/8, Fujichrome 64T, tripod. Photo above, right—Mamiya RZ 67, 110mm normal lens, one second, f/5.6-f/8, Minolta Spot Meter F, Fujichrome Velvia, tripod.

The play of natural light on architectural detail can be exquisite. These Moorish arches in the Alhambra in Granada, Spain, were illuminated by diffused light coming from an inner courtyard. The juxtaposition of the light and dark tones in the arches, as well as the perfect symmetry and elegant design, drew my eye.

Depth of field was a critical factor in this picture. If the foreground arch was sharp, while the other arches and facade were increasingly soft, the picture would have little impact. In order to create a composition tight enough to eliminate unwanted elements, I would need to use a telephoto lens. Unfortunately, telephotos inherently have shallow depth of field, so I must stop down to the smallest aperture possible.

I took the light reading with the one-degree Minolta Spot Meter F. I placed the meter's sensor on the center of the first arch, which I determined approximated medium gray, or the middle tone.

TECHNICAL DATA: Mamiya RZ 67, 250mm telephoto lens, one second, f/32, Fujichrome 50D, tripod.

Many of the world's great architectural wonders, especially older public buildings, are often poorly lit inside. Natural light entering through a few small, high windows sometimes offers only somber gloom in the space below. San Marco Basilica in Venice, Italy, is typical of these dim, interiors.

I could not bring lighting equipment inside this breathtaking cathedral, but I could do something to bring out the beautiful detail in the architecture and murals. A long exposure would make the interior appear much brighter in the photo than it did to my eyes. In fact, a long enough exposure would transform the cathedral, as though brilliant lights flooded the chamber.

My spot meter reading, taken from the center of the middle column, indicated four seconds at f/4.5. To make the picture lighter, I overexposed by one f/stop, eight seconds at f/4.5. The resulting brilliant gold decorations and the rich colors of the murals, so different from the somber tones I actually saw, make the picture successful.

TECHNICAL DATA: Mamiya RZ 67, 50mm wide angle lens, eight seconds, f/4.5, Fujichrome Velvia, tripod.

Special Conditions

One of the most challenging aspects of successful photography is determining the correct exposure. Every photographer knows this. As soon as we bought our first camera, the problem of obtaining an accurate light reading was immediately obvious.

There are two steps to determining exposure. First, you must know what kind of meter—reflective or incident—is best suited to a particular situation. Second, you must determine how to take the reading. Should the meter be used on the spot or average mode? In what direction should the white hemispherical ball of an incident meter be pointed? At what object in a scene should the light-sensitive circle of a spot meter be aimed?

There are, however, situations where the lighting conditions are so extreme that taking an accurate light reading is more challenging than ever. Sunlight on water or ice, shooting into the sun, patchy sunlight and lightning all pose special problems.

My approach to calculating exposure is rarely guesswork. Only in the most unusual circumstances—when no other options are available—will I guess at an exposure. Some professional photographers teach "guesstimating" in many situations, but I think this confuses rather than helps their students. Snow scenes are a good example of the ways "guesstimating" can trip you up. Some teachers tell photography students to take a light reading of a winter landscape covered in snow, and then open the lens aperture one-and-one-half stops to ensure a proper exposure. This approach is based on the theory that a camera's TTL meter will "see" the mantle of white snow as too bright. The meter, which is programmed for middle-toned subjects, then gives a reading that will turn the white into gray, effectively underexposing the whole image.

This is, in fact, true. You will get a meter reading of white snow that produces an underexposure. But how can anyone assume that all snow scenics should be overexposed by exactly one-and-one-half stops? Aren't there different kinds of snow conditions and weather? Snow illuminated by a bright sun in a clear, blue sky in the Rockies looks very different than it would under a deep overcast at sea level. What effect will the low-angled, golden light of sunrise have on snow? Does the same one-and-one-half stop suggestion apply? If the sun is glaring on icy snow, creating a blinding hotspot, should the exposure treatment be the same as when there's no hotspot?

It takes only a little thought to realize that each of these scenarios requires different exposures. So, don't guess or merely memorize a "rule." Solve exposure problems by reading a genuinely medium-toned area of the scene with either a TTL in-camera meter or a spot meter. Then use that exposure for the shot. Depending on the situation, an incident light meter may be the answer. It can read the light falling onto a scene when the light striking the meter is identical to the light illuminating the subject being photographed.

In the following pages you'll find examples of photos taken under difficult lighting conditions and learn how I determined the exposure for each. Use these examples as guidelines to help you when you find an extreme lighting situation in nature.

Shooting into the sun is always a tricky proposition. Even though I partially hid the ball of the sun behind the branches of this acacia tree in Kenya, it is still infinitely more brilliant than the backlit terrain. Note the whiteness of the sky. The hazy conditions on this late afternoon in Samburu Game Reserve precluded me from taking a light reading to the right or left of the sun in a more neutral portion of the sky. The only way to read the light accurately in this scene was to use a spot meter and find a small area of middle tonality in the golden-hued mountains or foliage.

If I relied on an in-camera TTL meter, the chances are good that one of two inaccuracies might have occurred. The sun and white sky could have fooled the meter into underexposing the image, or the darker terrain could have made the meter read the scene as middle gray and overexposed the image. Since it's difficult to always know how a TTL meter will react, I prefer to choose another, predictable metering method.

I selected the bottom portion of the distant escarpment to be the medium gray because it was approximately midway between light and dark. Therefore, assigning this area as the middle tone meant that the rest of the picture—the highlights, shadows and other medium-toned areas—would fall into place correctly. Once I had the reading, I made the exposure. If you're shooting with a 35mm camera, remember to take the camera off the automatic mode, and set the shutter speed and lens aperture manually before you shoot.

TECHNICAL DATA: Mamiya RZ 67, 350mm APO telephoto lens, 1/125, f/5.6, Minolta Spot Meter F, Fujichrome Provia 100. The camera and lens rested on a bean-bag placed on my safari vehicle.

A light meter is totally useless when you photograph lightning. The extreme contrast between the brilliant bolt and the ambient light in the sky can't be read accurately with any kind of meter. Instead, you must lock the shutter open with a locking cable release and wait until another bolt of lightning strikes. When it does, close the shutter, advance the film and open the shutter for another try.

Based on tests that I've done, the standard aperture for distant lighting is f/4 to f/5.6 and f/8 to f/11 for a closer strike when you're using medium-speed film. These settings are guidelines, but you do have great latitude when shooting lightning. Even with transparency film, you can be a full f/stop above or below an ideal exposure and still have a winning photograph.

It is much easier to capture the action of a lightning strike on film at night, because the shutter is open for a long period of time. The night sky has little effect on the film unless you are in or near a large city and the sky is artificially illuminated. It is a good idea, though, to sacrifice the unused frame and advance to the next one if no lightning flash occurs in a minute or two. Otherwise, when you do finally get a shot, you'll have a washed out sky that diminishes the impact of the lightning.

Daytime lightning bolts can be, and have been, taken, but it's not easy. Your timing must be perfect, so you can waste a lot of film before you finally capture the bolt. Daytime lightning shots are exposed as if the lightning isn't in the scene at all. A normal light reading can be taken of the scene before the bolt strikes.

TECHNICAL DATA: Mamiya RZ 67, 50mm wide angle lens, approximately one minute, f/5.6, Fujichrome Velvia, tripod. No filter was used; lightning usually photographs magenta.

Light coming from behind an ice field or a body of water at a low angle creates such brilliant highlights that an in-camera TTL meter can't read the scene correctly. Instead of a reasonable exposure, you will get a grossly underexposed picture that is so contrasty it will look almost black-and-white.

Don't try to read the subject. Instead, take the light reading from the sky with your camera's meter, and then use that shutter speed-f/stop combination to shoot the bright reflection. I have found that exposing for the blue sky gives consistently good results because it serves as a reliable middle tone. When you expose for a middle gray, all the other tonal values fall into place. If the sky isn't a rich blue, use a gray camera bag, your blue jeans or photo vest if these objects are middle-toned. I don't often bracket my photos anymore but, in extreme lighting conditions, it does guarantee that I'll return home with at least one perfectly exposed frame. Both these images would be perfect candidates for bracketing. Once the light reading is taken with a reflective meter, I will over- and underexpose the scene by one f/stop in addition to the exposure made using the meter reading.

TECHNICAL DATA: Ice—Mamiya RZ 67, 250mm telephoto lens, 1/30, f/16, Fujichrome 50D, tripod. Water—Mamiya RZ 67, 250mm telephoto lens, 1/125, f/8, Fujichrome 50D, tripod.

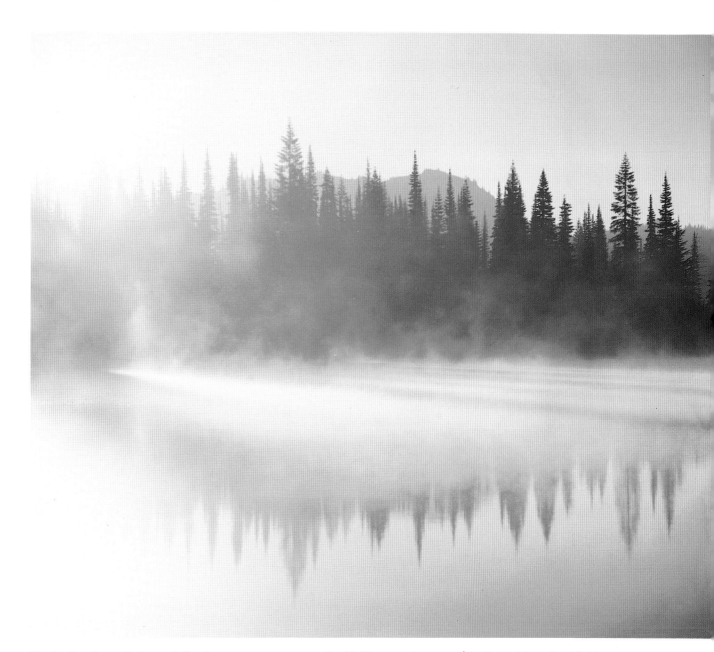

Shooting into the sun is always challenging, but when there is backlit fog plus a brilliant reflection on the water, it's as tough as it gets. I took this sunrise shot at Reflection Pond at the base of Mt. Ranier in Washington. I clearly remember standing before this beautiful scene wondering how I could possibly take an accurate light reading.

An incident meter can't read distant back lighting in nature, because the light source is behind it. (This includes sunrise and sunset skies, too.) If I turned the meter toward the light, it would read the light falling on the camera position but not on the brilliant backlit subjects.

A reflective meter, either the one in your camera or a hand-held one, such as the Minolta Spot Meter F that I use, will read a backlit subject. Since you must not let brilliant highlights adversely affect the reading, find a neutral-toned portion of the composition and take the reading from that.

I used the middle-toned area in the stand of pines dead center in the picture to take my spot reading. I determined that everything else would fall into place if this area was set as the middle of the tonal range. The highlights would be very bright and the darker parts of the frame would be correspondingly dark. I could have put my longest telephoto lens on the camera and used its spot meter mode to obtain the same

results I got with my hand-held meter. A telephoto lens narrows the field of view, working with the spot meter mode to read the light from a small area of the frame.

Note that a gray card or gray piece of fabric can't be used in this situation. A gray card is effective only when the light striking the card is the same as that illuminating your subject. My position was actually shadowed and about three f/stops darker than the sunlight. In this case, the light falling on the gray card wouldn't be the same as that backlighting the low fog.

TECHNICAL DATA: Mamiya RZ 67, 250mm telephoto lens, 1/125, f/8, Minolta Spot Meter F, Fujichrome Velvia, tripod.

The egret was fishing for its next meal in the Atchafalaya Swamp in Louisiana when I captured it on film from a boat. This shot represents a kind of contrast that is difficult for TTL meters to interpret correctly. All of the tones, except the bird, are virtually black.

Any reflective meter would read this low key scene and, according to the built-in programming, would set the darkness as a middle gray value. That would not only make the egret overexposed, but also wash out the richness of the tonality and destroy the haunting atmosphere of the swamp. You might think you could take a reading of the scene and close the lens down perhaps one or two stops to compensate for this error, but you would run into another problem. You wouldn't know precisely how much you should compensate and could still ruin the shot.

The best way to read this situation is to use an incident meter. The sky was overcast, so the entire area was receiving the same amount of light. In other words, the ambient daylight hitting the incident meter was the same as that striking the egret and the swamp. This means you can obtain an accurate reading.

TECHNICAL DATA: Mamiya RZ 67, 500mm APO telephoto lens, 1/60, f/6, Ektachrome 64 pushed three stops to ISO 400, tripod. I set up my tripod on the boat deck to take the weight of the camera and lens off my neck.

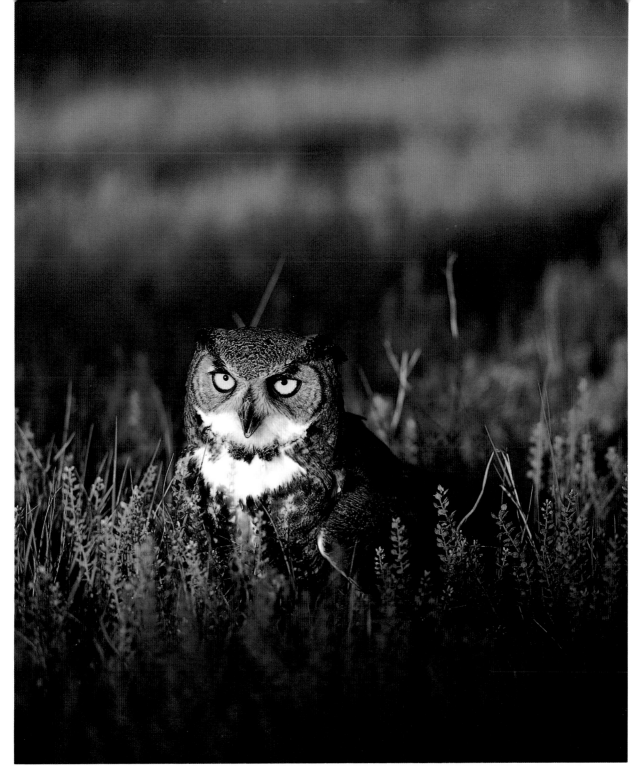

Patchy light makes it difficult to decide from which portion of the scene you should take the light reading. If you expose for the highlights, the shadow will go dark. If you expose for the shadows, the highlights will likely be overexposed.

When shooting slides it's a good rule of thumb to always take the light reading from the highlights unless you purposely want them washed out. Viewers are comfortable with dark shadows with little or no detail. Overexposed highlights, on the other hand, are rarely acceptable.

I exposed for the subject of this photograph, the face of the great horned owl, knowing that the shadows behind it would go dark. Since the camera position was also in the sunlight, I could use an incident meter to read the light. I could also have used a spot meter to assess the light from the bird's face. However, it would have been challenging to read the patchy light with an in-camera TTL meter, even if it has matrix metering capability. Matrix metering is a meter's ability to read several specific areas of a scene simultaneously and average them together, the center of the frame receiving the most consideration. I'm not saying it would have provided an inaccurate reading, only that it might have. Rather than take a chance, I rely on either a hand-held spot meter or an incident meter to read patchy light.

TECHNICAL DATA: Mamiya RZ II 67, 500mm APO telephoto, 1/125, f/6, Fuji-chrome Provia 100, tripod.

Neuschwanstein Castle in Bavaria, Southern Germany, is usually seen in travel brochures amid beautiful fall foliage or under a mantle of snow. I was there, however, on a rainy day in spring before leaves returned to the trees. I was disappointed but looked for a composition that might give me an artistic variation on the usual shots of this famous tourist attraction.

The best interpretation I could find was to shoot through the bare branches and include the white sky, something that is normally avoided. An overcast sky blocks a significant amount of sunlight from reaching the ground, but the sky itself is quite bright. In fact it is several f/stops brighter than the landscape below.

A meter reading that included even a small section of that bright, white sky would give me the wrong exposure. I could use the TTL in-camera meter only if I took the reading from the trees at the bottom of the castle, which are close to a middle tone. I wouldn't even trust the off-white tone of the building itself because it is a bit too light for a middle tone. I could, and did, use an incident meter instead, with the white ball of the meter pointing at the camera. The reading could only be taken out in the open, not in the forest, because the light striking both the meter and the castle must be the same.

TECHNICAL DATA: Mamiya RZ 67, 110mm normal lens, 1/30, f/8, Fujichrome Velvia, tripod.

These two shots of animal tracks in snow illustrate the subtle differences that the quality of light falling on the scene can create. The paw prints of the kangaroo rat, above, left, were photographed under a heavily overcast sky. The illumination was soft with no bright reflections back into the lens. At right is a shot of a print made by an unidentified animal in late afternoon light. Note that the highlights sparkling on the snow are created by backlighting, and that the quality of the light is very different from the photo above, left.

Don't let these photographs fool you into thinking both scenes reflected the same intensity of light. The reflected light on snow varies considerably, depending on the clarity of the sky, the angle of the light, and the time of day. The snow photographed under a low cloud cover, above, left, looked dull, while the backlit, sparkling snow above, right appeared much brighter. This difference in the quality of light is the reason you can't simply take a meter reading with your camera and "open up one-and-one-half stops to compensate for the white snow" as some professional photographers teach.

You can read this scene with a reflective meter pointing to a middle gray object, such as your camera bag or photo jacket. If you use an incident meter, the white hemispherical ball should point toward the camera lens as you frame the composition.

TECHNICAL DATA: Kangaroo Rat track—Mamiya RZ 67, 110mm lens, ¼ second, f/16, Fujichrome Velvia, tripod. Anonymous track—Mamiya RZ 67, 250mm telephoto lens, 1/30, f/16, Fujichrome Velvia, tripod. The exposures for both images were determined with a Minolta Flash Meter IV.

I found a mass of lady bugs on the side of a tree in the mountains near Flagstaff, Arizona. They were squirming over each other ever so slightly. The tree had a diameter of about fourteen inches, which meant the curvature of the trunk's surface was severe. If I focused on the ladybugs in the middle of the composition, the ones on either side would go increasingly out of focus because they curved away from the plane of focus.

To make matters worse, the insects were in deep shade. A fast shutter speed would freeze any movement, but the light didn't permit a brief exposure time. I would have to be only a few inches away when I took the shot to get the right amount of detail. When the subject to camera distance is that short, the depth of field becomes extremely shallow. There wasn't enough light for the very small lens aperture required for proper depth of field, because a long shutter speed would show the insects' movements.

Given the diminished light and the insects' slow movements, how could I get the right exposure, ensure a sharp image and still have enough depth of field to keep focus throughout the frame? Not with the available light. The only solution was to override the natural light of the forest by using a flash. The artificial light would provide enough illumination to use a small lens aperture, and the exposure time would be the flash duration, a short enough period to freeze movement.

The Mamiya RZ synchronizes any shutter speed with flash. I used a shutter speed of 1/125th of a second, but I could have used a speed from 1/30th or faster, and the exposure would have been unaffected. If a speed slower than 1/30 were used, there would be a risk of the ambient light imprinting an image on the film over the flash exposure and ruining the result.

Although this is a book on shooting with natural light, I included this photo to remind you that we have to be flexible, and prepared, when shooting outdoors. I use available light for most of my outdoor shots—as I did for every other shot in this

book—but always carry at least one flash unit with my gear in case I run into a situation where added or artificial light is the only solution. On the other hand, don't let yourself get dependent on your flash. Nine times out of ten, you can come up with a great shot, even if it's not the one you wanted, using available light. Use the flash when that's the best, or only, option you have.

TECHNICAL DATA: Mamiya RZ 67, 110mm normal lens, #1 extension tube, 1/125, f/22, Vivitar 285 flash mounted directly above the lens, exposure determined by a Minolta Flash Meter IV, Fujichrome 50D, tripod.

You should usually avoid shooting in patchy sunlight because it's almost impossible to make an exposure that does both the shadows and the highlights justice. Once in a while, however, you can pull off a good shot.

I photographed this albino barred owl at the base of a tree with sunlight filtering through the leaves high above it. The contrast between the sunlit portion of the bird and the shadowed portion of the frame was about four f/stops. I knew that setting an exposure between the two extremes would lighten the shadows and show more detail in them, but the highlights would be washed out. Then, the beautiful detail in the brilliant white feathers of the bird wouldn't show.

I opted to expose for the highlights instead. You can get away with dark shadows, but washed-out highlights look awful. Next, I had to decide what meter I should use. A TTL in-camera meter might work, but I wouldn't trust its results, even if it had the sophisticated matrix or evaluative meters you find on top-of-the-line Nikon and Canon 35mm cameras. A spot meter was also problematic, because there wasn't a middle-gray region in the framed scene. Consequently, I used an incident meter placed so the sun could fall upon it exactly as it fell through the leaves onto the owl. This gave me the exposure you see here.

TECHNICAL DATA: Mamiya RZ 67, 350mm APO telephoto lens, 1/125, f/8, Minolta Flash Meter IV, Fujichrome 50D, tripod.

Long exposures in dark conditions can cause the natural light to appear brighter in a photo than it really was is, as with this artistic interpretation of Antelope Canyon near Page, Arizona. Daylight enters through a narrow slot in the rocks eighty feet above the canyon floor; where it reaches the bottom, the rock walls appear eerie and fanciful in the gloom. Only a long exposure could put color back into the sandstone and increase the apparent illumination level.

The rock walls receive more exposure closer to the opening at the top of the canyon, although they still aren't very bright. I chose one of the lighter sections from which to take a reading with my spot meter. I recognized that my choice meant some of the frame would be slightly overexposed, but I wanted to hold the subtle shading in the shadows. If it were underexposed by even one f/stop, all of the detail in the darkest part of this photo would have been lost.

An incident meter wouldn't work here because the light where I stood on the canyon floor was quite different from that forty or fifty feet above me. There was no way I could place the meter in the same light to take an accurate reading. That's why the spot meter proved so valuable here.

TECHNICAL DATA: Mamiya RZ 67, 250mm telephoto lens, eight minutes, f/22, Minolta Spot Meter F, Ektachrome 64, tripod.

This portrait of three young members of the Maasai tribe in Kenya presents a classic dilemma faced by photographers in sub-Saharan Africa. In bright sunlight, with light-toned elements in a scene, how do you expose for the black skin of the indigenous people?

Photographs of people are usually considered properly exposed when the skin tone is correct and, in fact, the tonality of the skin of many subjects is very close to middle gray. African peoples, on the other hand, frequently have skin so dark that it is not a middle-toned area. This means you can't take a light reading from your subject's face because the skin would be inappropriately light and the background overexposed.

The easiest solution to this exposure problem is to point your TTL or spot meter at a middle-toned object in the scene instead of the face. For this shot I could have used a section of the blue sky, the tall grass, or the red fabric worn by the tallest Maasai. Another approach would be to hold an incident meter toward the camera and read the sunlight as it falls simultaneously on both the subjects and the meter.

TECHNICAL DATA: Mamiya RZ 67, 250mm telephoto lens, 1/250, f/8-f/11, Fujichrome Provia 100, tripod.

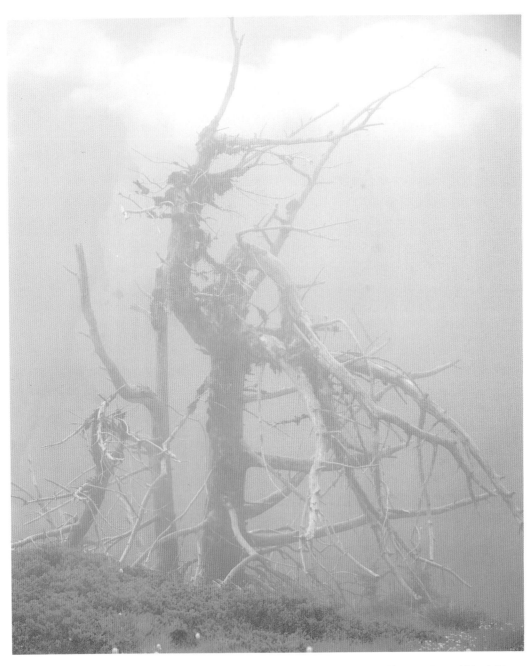

This shot of a tree, shrouded in dense fog, on Hurricane Ridge in Olympic National Park, Washington, was taken in conditions that made it hard to judge my exposure. Fog or low clouds are made up of minute water particles suspended in the air that amplify the ambient light to a brilliant white. A reflective meter pointed at the fog sees it as the medium gray tone, a reading that would give you a grossly underexposed picture. So, you would have to point it at a neutrally toned subject, such as a piece of gray fabric sewn on your camera bag. If you were using your camera's TTL meter, you would then take it off the automatic mode, switch to manual, and use that reading for the shot.

I used my incident meter to determine the exposure for this image because fog is one of the easiest conditions for a hand-held incident meter to read. The light is soft and low in contrast, with no shadows or highlights. It falls on the meter with the same level of brightness as every other sub-ject within sight.

The meter's white hemispherical ball still has to face the camera when taking the reading, because the light will be slightly brighter from the direction of the sun even under a dense cloud cover. This difference may be only one-third or one-half f/stop, but that is still enough to affect the quality of a shot.

TECHNICAL DATA: Mamiya RZ 67, 250mm telephoto lens, 1/30, f/5.6, Fuji-chrome Velvia, tripod.

There are few situations, besides lightning, that are impossible for a light meter to read properly. This waterfall inside a mountain in the Jungfrau region of Switzerland is one of them. The rock walls were very dark, and the falling water was illuminated by a tiny opening in the roof of the cavern and several mercury vapor lights. The viewing area where I could position my camera was not receiving the same illumination as the falls, which made the use of an incident meter impractical. The harsh illumination from the lights made the scene so contrasty that there was no middle tone to read with a reflective meter or a hand-held spot meter. I couldn't use my gray camera backpack as a medium gray for the meter reading either, because I was standing in the dark.

The only thing I could do was guess. I bracketed the exposure by one f/stop on either side of the estimated exposure. My guesstimate was twenty seconds. One f/stop underexposed was ten seconds, and one f/stop overexposed was forty seconds. I knew the water would be dramatically blurred, a nice effect with falling water.

A flash would have frozen the droplets as they fell, but I didn't want to use the flash for two reasons. First, the light of the flash would have destroyed the dramatic shadows and highlights created by the placement of the mercury vapor lights. The strobe's flat light would be dimensionless. Second, the walls would have been their natural gray color in the correctly balanced light from the flash. I knew that mercury vapor illumination produces a blue-green cast that I felt would add to my artistic interpretation of this special place.

The roar of the falls echoed within the cold cavern, and fine water particles hung in the air. I used a rubber lens shade to protect the front element of the lens from the constant mist, but I still had to clean the lens every thirty seconds.

TECHNICAL DATA: Mamiya RZ 67, 50mm wide angle lens, twenty seconds, f/4.5, Fujichrome Velvia, tripod.

Index

A
Animals, 15, 23, 26, 37, 39, 60, 63, 94,
 see also Wildlife
Aperture, 21
 maximum, 64
Architecture, 114, 115
Art, works of, 109, 115

B
Backgrounds, 43, 63, 89, 93
Back lighting, 9, 67, 121, 125
Bellows, 99
 extension, 103
Bracketing, 120, 131

C
Cameras, position of, 1
 Mamiya RZ 67, 29, 110
Canyons, 24, 54, 69, 129
Catchlight, 15, 26, 60
Cathedrals, 78, 105, 106, 110, 115
Children, 22, 47
City scenes, 24, 78, 82, 83, 86
 at twilight, 75, 83, 86
Close ups, 29, 99
Clouds, 10, 54, 69, 83, 85, 96, 130
Color
 and images, 94
 and temperature, 53
Composition, 9, 44
 white in, 10
Contrast, 9, 23, 64, 66, 107
 and drama, 66

D
Dawn, 6, 9, 11, 53
Depth of field, 21, 64, 91, 98
 and close ups, 99
 increasing, 103
Diffused light, *see* Light, diffused
Diffusion panels, 89
Dust, and cameras, 68

E
Eiffel Tower, 25
Equator, the, 29, 30, 42
Equipment, caring for, 86
Exposure compromise, 13, 108
Exposures, 3, 53
 for daylight film, 53
 determining, 107, 117
 problems, 117
 and white skies, 100
Extension tubes, 99

F
Faces, 22, 35, 47, 50
 and hats, 30

 and shadows, 50
Film, 60, 64, 84, 105
 color saturated, 60, 89
 and color temperature, 53
 daylight-balanced, 53, 80, 105, 113
 Ektachrome 50T, 81, 105
 Ektachrome 160T, 105
 Fujichrome, 25
 Fujichrome 50D, 42, 89
 Fujichrome 64T, 53, 80, 81, 89, 105
 Fujichrome 100D, 64, 95
 Fujichrome Provia 100, 84, 89, 98
 and wildlife, 89
 Fujichrome Provia 400, 89
 Fujichrome Velvia, 48, 53, 78, 80, 84,
 89, 98, 103, 105, 113
 Kodak Ektachrome, 84, 89
 Kodak Lumiere, 53, 84, 89, 105
 latitude, *see* Latitude, of film
 pushing, 95, 110
 transparency, 69, 107, 119, 123
 tungsten, 80-81, 89, 113
 tungsten-balanced, 105
 Velvia, 42, 64
Film plane, 91, 92
Filters, 28, 34, 48, 73, 77
Flash, 126, 131
 meter, 47
 Minolta Flash Meter IV, 47, 61
 photography, 1-5
 Sunpak, 105
 Vivitar, 105
Fog, 10, 18, 121, 130
Frost, 15, 19
Front lighting, 16, 25

G
Glaciers, 90, 96

H
Highlights, 69, 107, 127

I
Ice, 90, 120
Indoor
 lighting, 105, 108
 photography, 105

K
Kelvin temperature, 53
Keystoning, 92, 102

L
Landscapes, 41, 75, 97
Latitude, of film, 9, 57, 75, 107, 108
Lens aperature, 64
Lenses,
 choosing, 87

 and depth of field, 114
 fisheye, 111
 18mm fisheye, 110
 flare spots within, 65
 macro, 99
 Mamiya 37mm fisheye lens, 110
 Mamiya RZ 50mm wide angle, 44
 Mamiya RZ 110mm, 110
 telephoto, 18, 39, 46, 60, 73, 90, 92,
 106, 121
 250mm, 94
 300mm, 21
 wide angle, 18, 21, 38, 41, 45, 50, 64,
 67, 73, 106
 24mm, 44
 and enlarging images, 51
Light
 artificial, 105, 109
 diffused, 1, 89, 95, 98
 animals and, 95
 and macro photography, 99
 people in, 92, 93
 direction of, 16, 94
 directionless, 11
 even distribution of, 91
 low-angled, 14, 15, 16
 and wildlife, 60
 midday, 37-51
 morning, 17, 24
 natural, 107, 108, 110
 and architecture, 114, 115
 and people, 110
 overhead, 14, 30, 32, 37, 43, 44
 patchy, 123, 127
Light meters, 53
 averaging, 112
 incident, 22, 26, 71, 73, 102, 105,
 117, 122
 and back lighting, 121
 and fog, 130
 hand-held, 3, 11, 90, 97
 how to use, 117
 and overcast skies, 124
 and patchy light, 123, 127
 and skin, 129
 and snow, 125
 Matrix metering, 123
 Minolta Flash Meter IV, 90, 110
 Minolta Spot Meter F, 65, 106, 114,
 121
 readings, 67
 reflective, 3, 11, 67, 73, 90, 102, 120
 and backlighting, 67
 and fog, 130
 hand-held, 101
 and snow, 125
 spot, 13, 18, 70, 93, 112, 118, 129
 in dark conditions, 128

More Great Books to Help You Sell What You Shoot!

1997 Photographer's Market—Discover more than 2,000 up-to-date listings of U.S. and international buyers of freelance photos. Each listing contains contact names, submissions requirements, photo specifications, pay rates and tips from the buyer on how to "break in" with that market. You'll find everything you need to increase your sales and success! #10458/$23.99/672 pages

Sell & Re-Sell Your Photos, 4th Edition—Focus your goals and improve your profit picture! In this detailed revision, Rohn Engh has expanded his coverage to include even more on marketing principles, pricing, self-promotion and the latest technology—everything you need to sell your work. #10499/$16.99/368 pages/paperback

How to Shoot Stock Photos That Sell, Revised Edition—Get terrific shots of the subjects that stock photo houses clamor for! You'll discover 35 step-by-step assignments on how to shoot for these markets, including stock ideas that photographers haven't thought of, those that were tried but in the wrong style and those for which there is never enough coverage. #10477/$19.95/208 pages/20 b&w illus./paperback

Professional Photographer's Survival Guide—Earn the most from your photographs! This one-of-a-kind book guides you through making your first sale to establishing yourself in a well-paying career. #10327/$17.99/368 pages/paperback

The Professional Photographer's Guide to Shooting & Selling Nature & Wildlife Photos—This all-in-one guide shows you the ins and outs of capturing the wonder of nature in photos. Plus, you'll get great advice on how to market your work. #10227/$24.99/134 pages/250 color photos/paperback

How You Can Make $25,000 a Year With Your Camera—This one-of-a-kind guide shows you how to uncover photo opportunities in your own community! You'll get special sections on pricing and negotiating rights, boudoir photography. #10211/$14.99/224 pages/46 b&w illus./paperback

Creative Techniques for Photographing Children—Capture the innocence and charm of children in beautiful portraits and candid shots. Professionals and parents alike will create delightful photos with dozens of handy hints and loads of advice. #10358/$26.99/144 pages/paperback

Stock Photography: The Complete Guide—Discover how to break into this very lucrative market! Two highly successful photographers show you what to shoot, how to organize your pictures, how to make the sale and more! #10359/$19.95/144 pages/paperback

A Guide to Travel Writing & Photography—This book introduces you to the colorful and appealing opportunities that allow you to explore your interest in travel while making a living. #10228/$22.95/144 pages/80 color photos/paperback

Outstanding Special Effects Photography on a Limited Budget—Create eye-popping effects (without busting the bank)! Dozens of tips and techniques will show you how to make the most of your equipment—and how to market your dazzling shots. #10375/$24.95/144 pages/175+ color photos/paperback

Lighting Secrets for the Professional Photographer—Don't be left in the dark! This problems-solutions approach gives you everything you need to know about special lighting tricks and techniques. #10193/$26.99/134 pages/300 color illus./paperback

Handtinting Photographs—Learn how to use handtinting to reveal detail and change emphasis. You'll discover information on materials, techniques and special effects. #30148/$32.99/160 pages/color throughout